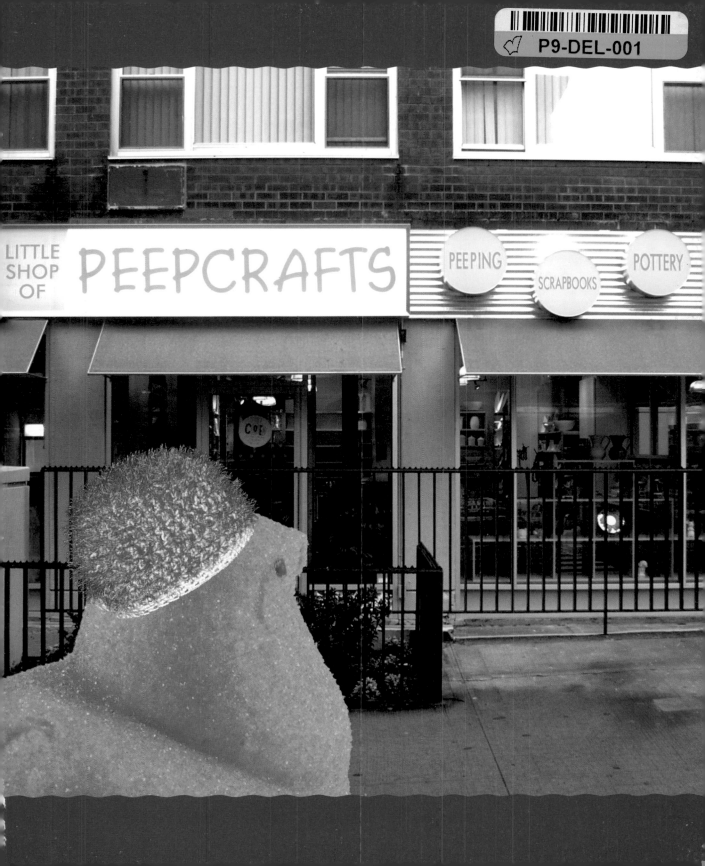

Entries/Entrées  *Visas*  Departures/Sorties  En

# PEEPS® AHOY!

## A Candy-Coated Adventure on the High Seas

**MARK MASYGA** AND **MARTIN OHLIN**

S.S. GOOF-2

ABRAMS IMAGE • NEW YORK

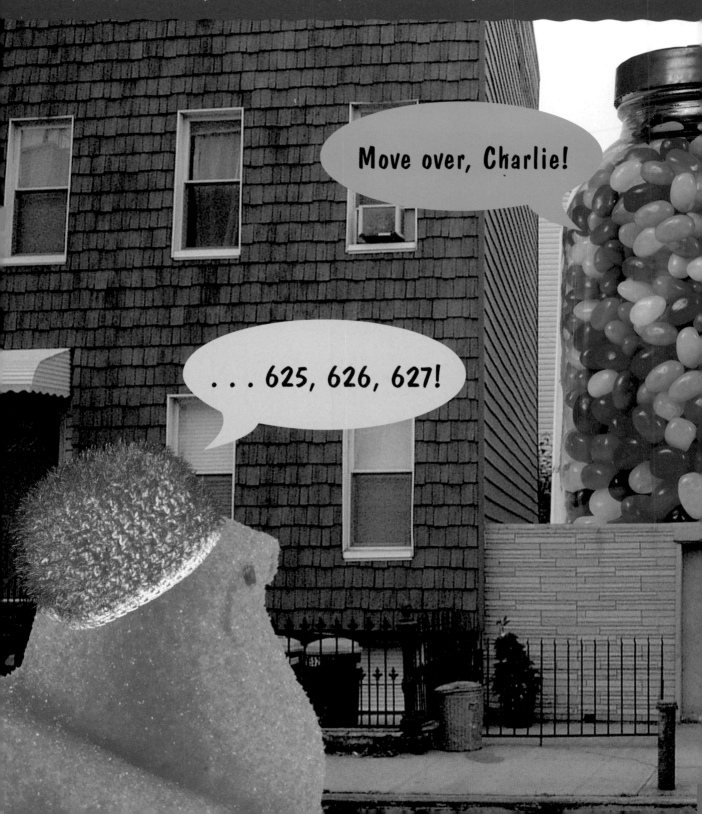

# The Peeps

VOL. XXVI...NO. 68,292     PEEPSVILLE

# Local Peeps Chick Wins Fancy Trip

PEEPSVILLE — It's sweet sailing for one lucky Marshmallow Peeps family! They're off to see the world aboard the luxury liner GooE2. Mother Peeps has won the grand prize in PS 627's annual spring fundraiser by correctly guessing the number of Teenee Beanees crowded into the newly constructed elementary school.

"We would like to thank Captain Jimbo Sparkles of the GooE2 for donating the wonderful prize," said PTA president Jessica Sugarbeak. The family cruise is valued at over $50,000. "We raised $17 for new gym equipment. Everyone's a winner!"

"I'm tickled pink," said Mrs. Peeps. "This is almost as thrilling as when I won the scrapbooking competition at last year's county fair."

Mrs. Peeps will be accompanied by her husband, Father "Pops" Peeps, and their two children: son Parker, 15, and daughter Pretty Sue, 13. "My husband is looking forward to a monthlong nap in a deck chair," she said. "Parker and Pretty Sue will sparkle everywhere we go."

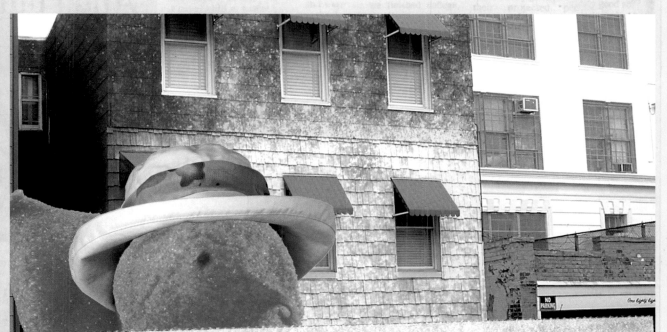

PEEP BANK 5325

68-7268/2680
01

Date _____

$ **$50,000**

Pay to
the order of    **Mother "Mom" Peeps**

**Fifty thousand and no/100**     Dollars

For   **Family Cruise**

⑆2560 2560 ⑈ 22560 25608⑈ 2560

"I love to count," said Mother Peeps, who estimated the number of students at 627. "As a tiny chick, I would count how many sugar cubes were left on the platter and eat fast enough to secure seconds."

Mrs. Peeps's chief scrapbooking rival, Madge Stabberbach, has liquidated her retirement savings and purchased a berth on the GooE2. "I'm convinced Mother Peeps cheated," said Ms. Stabberbach. "Nobody can count up to 627. Mother will do anything to collect material for her travel scrapbook. She probably thinks her efforts will win the blue ribbon at the Peepsville County Fair. Well, not if I can help it! Everywhere she goes, I'll be one step behind, collecting the same great photographs, the same colorful ticket stubs, the same bits of lovely detritus that make scrapbooking so addictive. I'll win that blue ribbon, or my name's not Madge Yurlinda

Durleen Charlene Tiffany Stabberbach!"

Mrs. Peeps welcomes the competition. "I met Madge last fall at the Peepsville County Fair, where we competed in the prestigious scrapbooking competition," she said. "I won the blue ribbon. Madge was a distant second. She's insanely jealous of my success, and a huge boost to my ego! Our scrapbooking club meets every Thursday at her lovely ranch-style home. Last week, Madge accidentally spilled a bottle of india ink on one of my most intricate layouts. She keeps me on my toes and at the top of my game. I don't have toes, but you know what I mean."

"I'm spending my last dime on this cruise," said Madge Stabberbach. "It will be worth it when my travel scrapbook wins the blue ribbon at the county fair."

PEEP I
PEEPDORAS
PEEPSON ·
VELOU

## PEEP GIFT SHOP
FRAPPES · WATCHES · PERFUMES · TO
17117 PEEPARD STREET

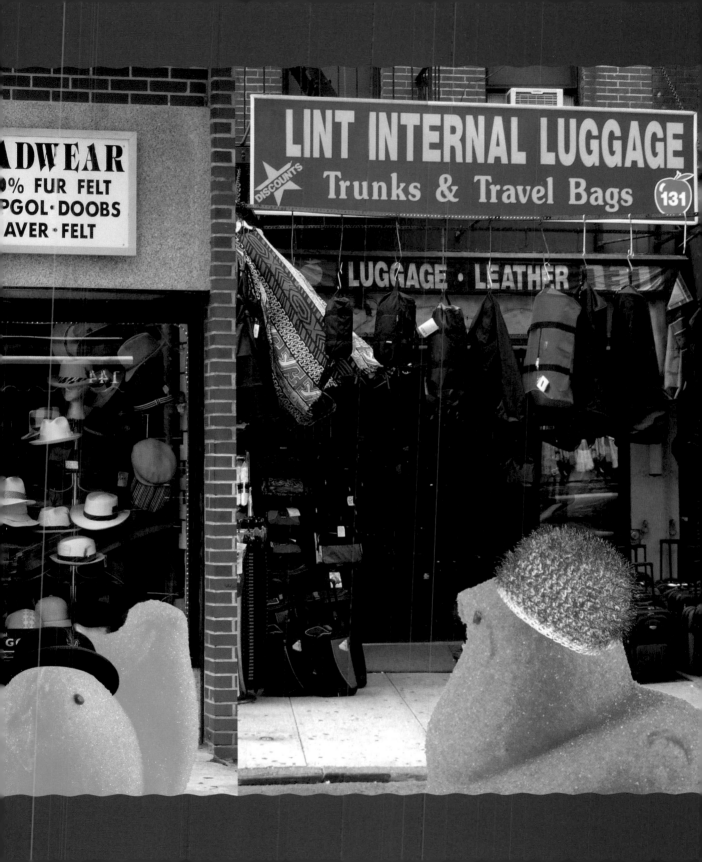

# Prominent Architect Sued by Concerned Parents

## *George Peeps's School for Teenee Beanees Deemed Overcrowded*

PEEPSVILLE — PS 627 opened two weeks ago and the local PTA is already calling for its lid to be screwed shut. "My son Bruno has to share his desk with six other students," said Deborah Simpleshape, outraged mother of a third-grade Teenee Beanee. "He can't concentrate on his penmanship. He can't see the blackboard. Hiring a big-shot architect like George Peeps was a mistake. Function should count as much as form, don't you think?"

Other parents voiced similar complaints. "My daughter Tammy Sue cries every morn-

### "I don't understand these Teenee Beanees."

ing," said Richard Jellykin, father of a kiwi-flavored kindergartner. "She can't remember her ABC's and has misplaced her lunch box three times in the last week. We should call in the wreck-

ing ball and hire an architect who is more sensitive to the needs of our community."

"I don't understand these Teenee Beanees," said prize-winning architect George Peeps. "I've designed an elegant, glass-curtained structure that would be the envy of any city in the world. Teenee Beanees might be delicious, but they know nothing about contemporary architecture."

"We don't need an architect who thinks outside the box," said Mrs. Simpleshape. "A box would be just great."

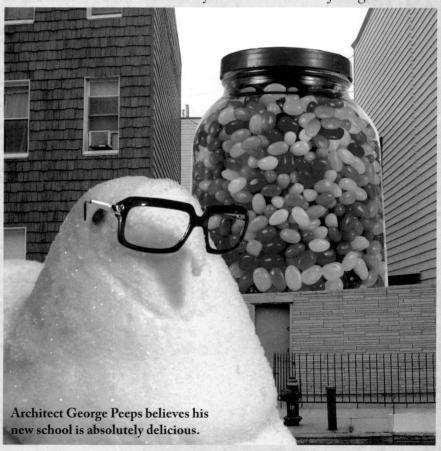

**Architect George Peeps believes his new school is absolutely delicious.**

# Going Out of Business Sale!
## Everything Either Must Go or Has Gone.
*"Get the Lint out of your pocket and into our luggage."*

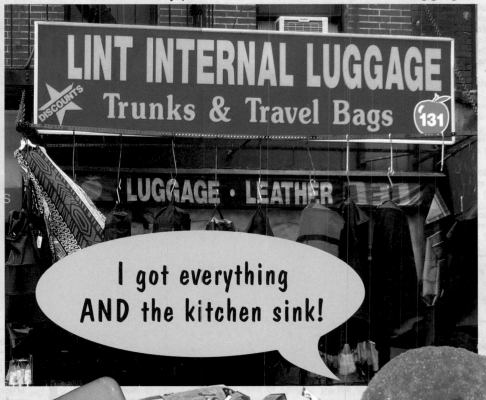

# Peeps Bunny Reads Seven Books

**By Sylvia R. T. Syrup**

PEEPSVILLE — Katie Bunny, a 38-year-old Peeps Bunny from the Sugar Beach neighborhood, has met her monthly goal of reading seven books. She will not receive an impressive certificate from Peepsville mayor Crystal Peeps. She will not be awarded a cash prize. Amazingly, Ms. Bunny reads for her own personal enjoyment. "Reading is fun," she said. "I am allowed to read whatever I like. Isn't that marvelous?"

Judy Peepsquatch, who drives the Bookmobile every third Wednesday of the month, delivered seven new books to Ms. Bunny's condominium. "Katie was too busy reading to visit the library," said Mrs. Peepsquatch. "She reads every single day. When Katie doesn't understand a word, she looks it up in the dictionary. Her latest word is 'marvelous.' After she learns a new word, she likes to use it in a sentence. She has a huge vocabulary."

Ms. Bunny says her favorite book is *Peeps: A Candy-Coated Tale*. She has read it 27 times and recommends it to everyone. Someday, Ms. Bunny hopes to write a book of her own. "It will be about a family of Peeps who win a marvelous trip on a cruise ship," she said. "Wouldn't that be a marvelous book? I hope no one steals my marvelous idea."

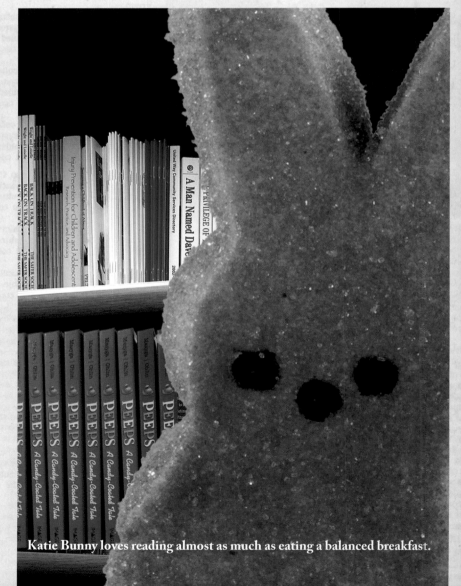

**Katie Bunny loves reading almost as much as eating a balanced breakfast.**

# Peepsquatch Marries Blankie Egg

## Urban Legend and Fetching Fashionista Will Honeymoon Aboard the GooE2

**By Dolores Dollops**, *Society Page Editor*

PEEPSVILLE — The Peepsquatch and Blankie Egg exchanged nuptial vows last Saturday in a secret ceremony held behind a Dumpster. "I love the Peepsquatch," said Blankie Egg. "He is absolutely gorgeous, with his rich white frosting and beady little red eyes. I feel stylish standing next to him, no matter what cute outfit I might choose to wear. A Peepsquatch is the ultimate accessory!"

The bride, 26, is the daughter of Humpty D. Egg, who sits on the wall, and Fabber J. Egg, who has never worked a day in her life. "I do not approve of this marriage," said Mrs. Egg. "My daughter married a frosted freak just to spite me. Merciful heavens, is it my fault she was born without a face?"

The Peepsquatch, 38, is the son of Mike and Judy Peepsquatch, address unknown. The groom's father, like his son, is self-employed as an urban legend, darkening the dreams of local Peeps candies. His

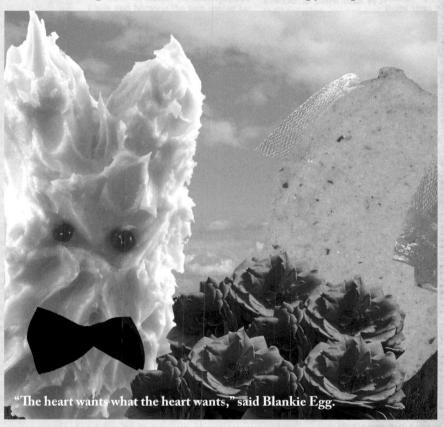

"The heart wants what the heart wants," said Blankie Egg.

mother is an assistant librarian at the Peepsville Public Library. She drives the Bookmobile every third Wednesday of the month.

After honeymooning aboard the GooE2, the couple will reside in sleepy Peepsville Acres.

"Mother built us a fancy mansion on a remote 32 acres," said Blankie. "She thinks a quiet life in the country will keep us out of the gossip columns."

# We May Be Creamed, Cloud Docs Warn
## Are Dangerous Icecreambergs Next Threat to Our Society?

By Toggle Q. Waxlips

PEEPSVILLE — This Peepsville Currant reporter has the scoop on our rapidly melting ice-creambergs, with a firsthand taste of what is to come. And it is sweet. Although the public may be warming to the idea of the endless summer, climate change is now putting us in a sticky situation, as evidenced by the recent landslide of nuts on Mount Cashew Picchu.

"I heard a popping sound, sort of like someone popping bubble wrap," said hiker Scoots Filbert. "When I looked up, a wall of walnuts was toppling over onto me!" Local geologist and climatologist Professor Fran Tastybib surmises that years of decornestation and higher-than-normal levels of fructose farming have raised the median temperature by .03 degrees Fahrenheit, contributing to a rapid meltdown of ice-cream ranges the world over. "We've seen it in samples of underground fudge in the West," Dr. Tastybib explained

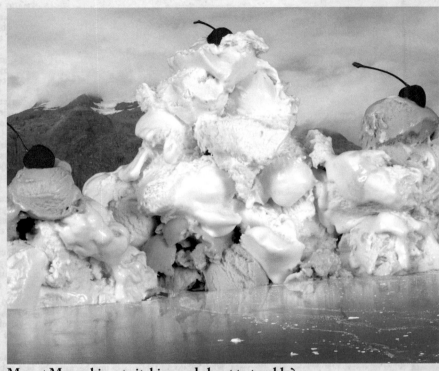

Mount Maraschino, twitching and about to tumble?

over a cup of mochaflubboccino, "and we found molten rivulets where glacial flows used to be. This is serious."

The change from solid to molten fudge—dubbed "fudge-sludge"—has ramifications in the upper strata, causing layers to shift and become unstable. Walnuts, chocolate shavings,

## "This is serious."

and sprinkles have all been seen, and felt, shifting around the world.

Eyewitnesses claim to have seen Mount Maraschino wiggle its glossy stem as if tweaked by some giant finger. Dr. Tastybib cautioned, "If left unchecked, this rapid shift in temperature could cause icecreambergs to break free, posing dangers for seafaring vessels the world over."

# Fun Page!

## Which One Doesn't Match?

## Crazy Maze

*(difficulty rating 6.27)*

begin

end

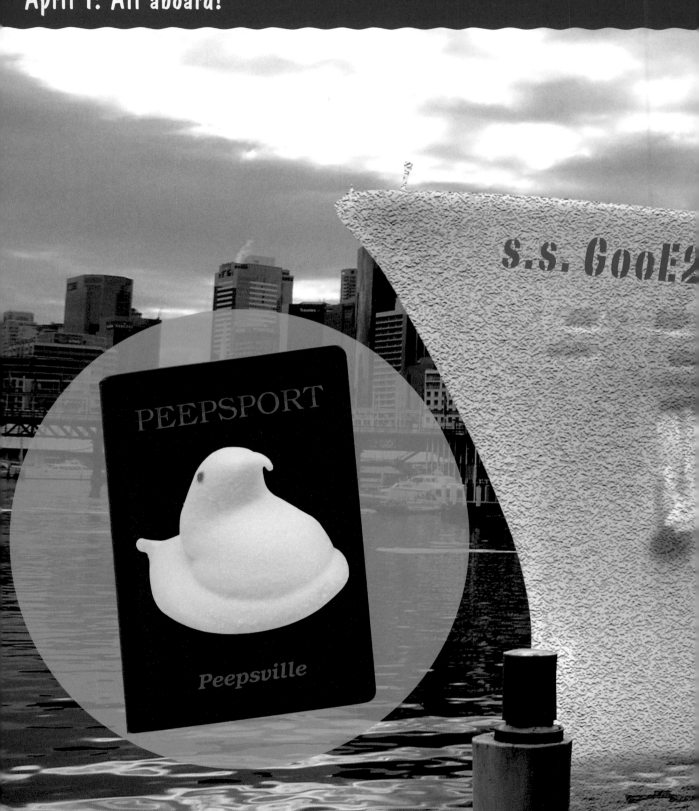

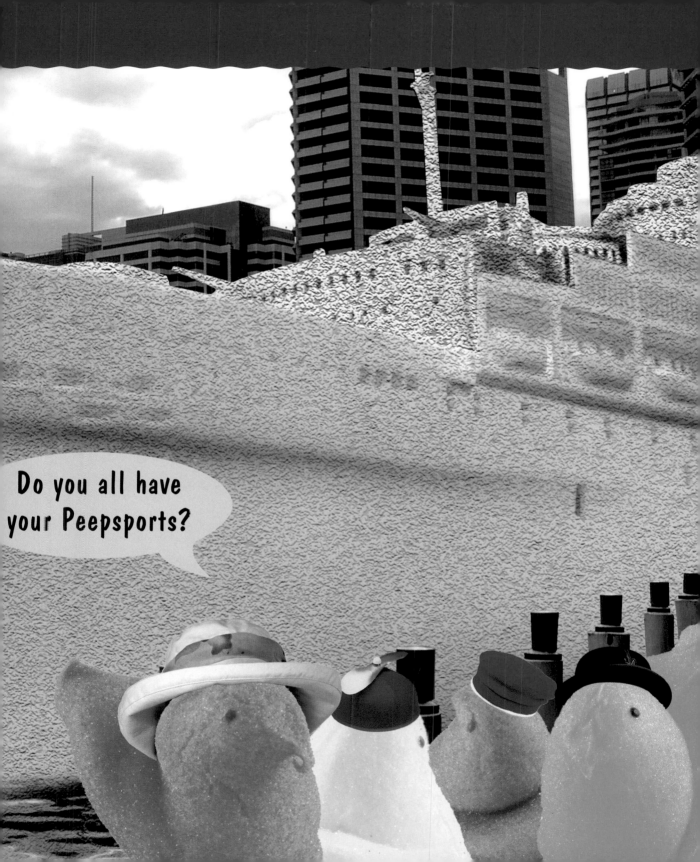

Bon voyage, and sweet sailing!

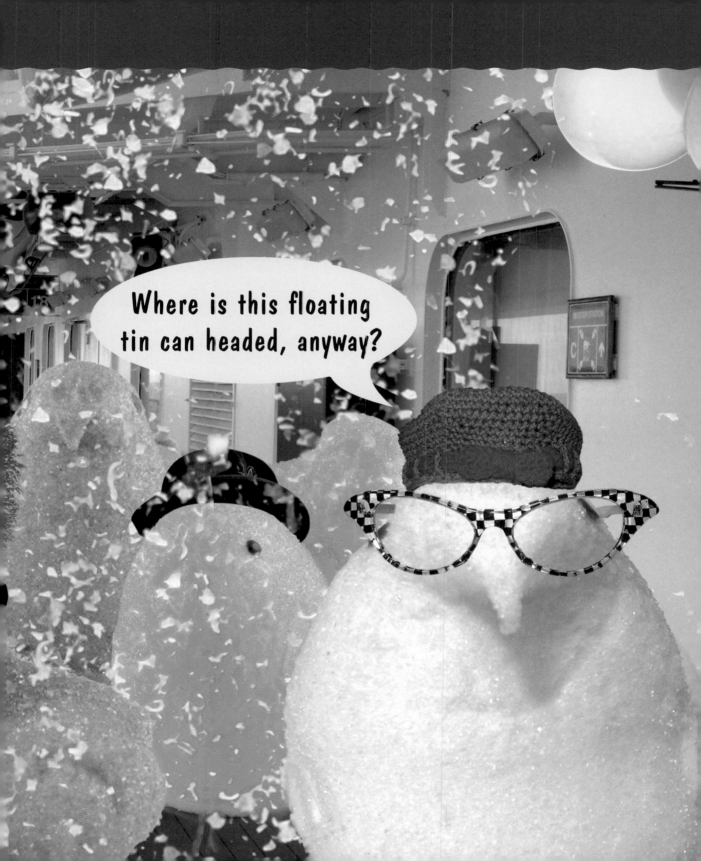

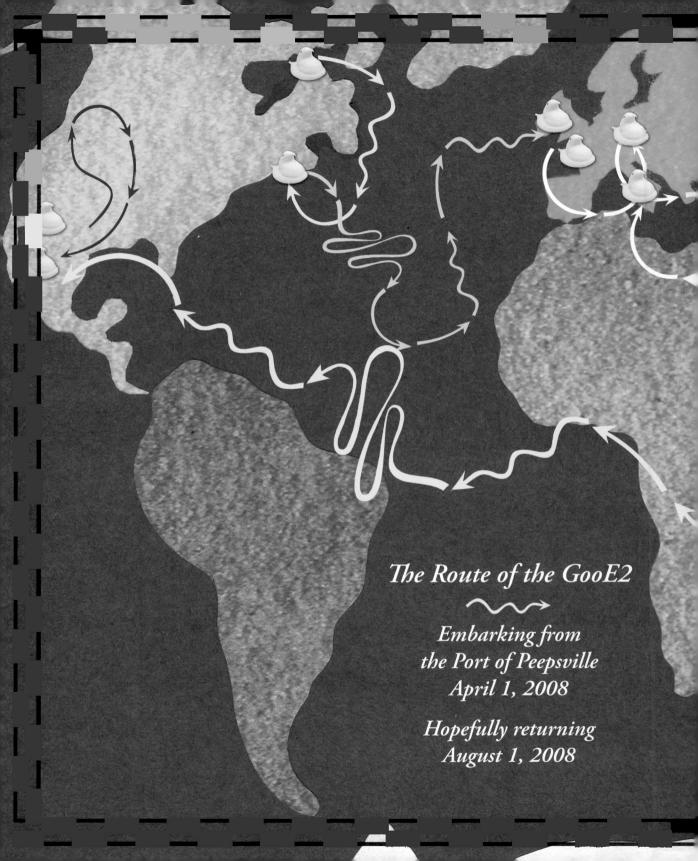

The Route of the GooE2

Embarking from
the Port of Peepsville
April 1, 2008

Hopefully returning
August 1, 2008

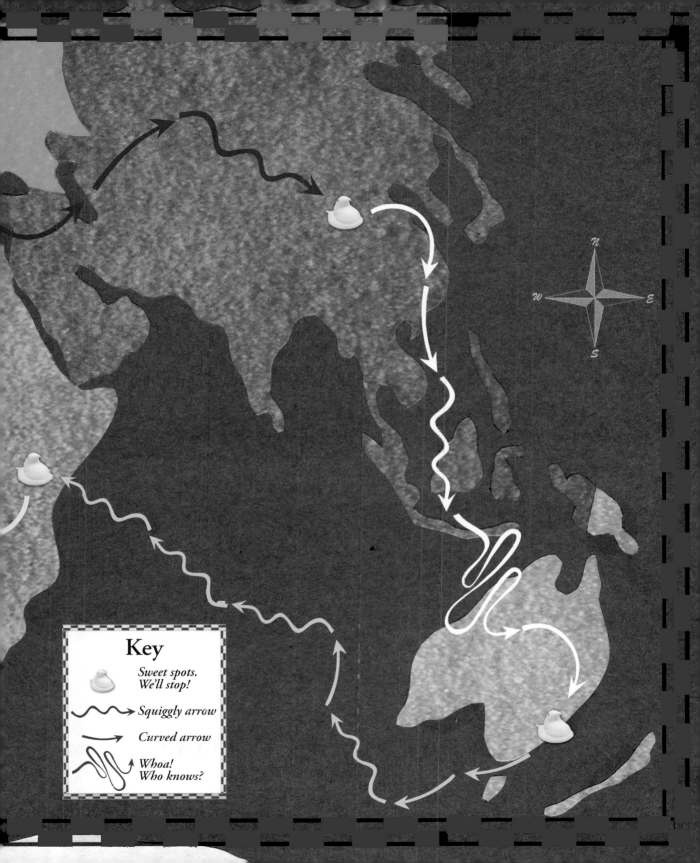

Key

Sweet spots.
We'll stop!

Squiggly arrow

Curved arrow

Whoa!
Who knows?

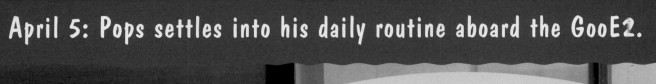

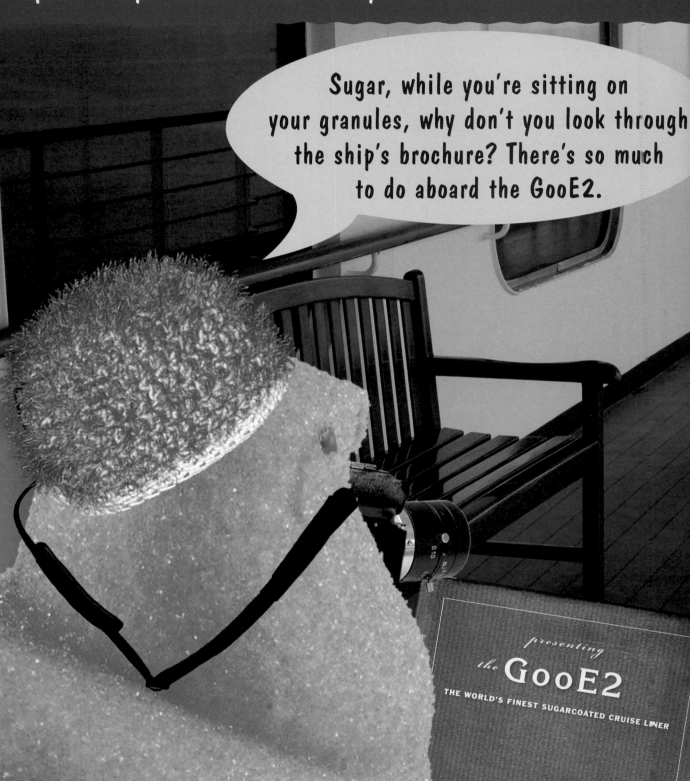

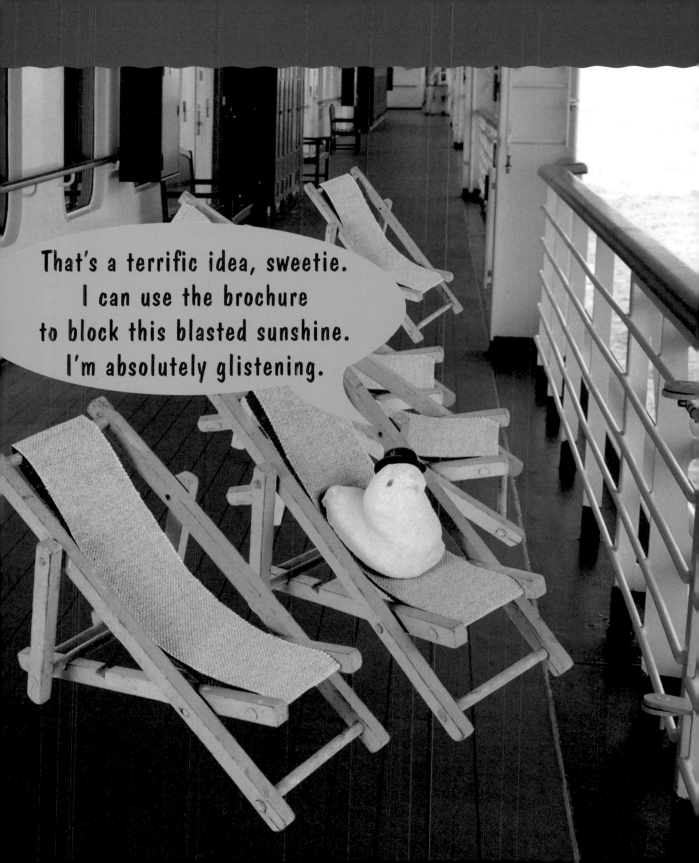

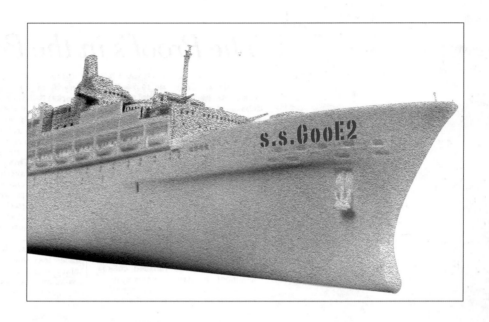

## *Her "Sweetness"*

Constructed to the highest candy-ship building standards in the Port of Peepsville, 2007.

You may cruise in complete confidence, knowing that her hull is built of the strongest spun sugar, tested to tolerate forces up to (but not including) accidental impact with an icecreamberg.

Our hopelessly quixotic planning puts the sweet taste of discovery back into travel.

The GooE2 is the ideal candy-coated cruise liner, and combined with an itinerary that is nearly impossible to chart, plus novice direction and management (both at sea and onshore), it is certain to offer you the sugar rush of a lifetime.

# Welcome Aboard the GooE2
# The World's Finest Sugarcoated Cruise Liner.

## ITINERARY
This company offers an unparalleled opportunity of the sweetest nature for experienced and inexperienced treats to tour the world, including such destinations as:

- Niagara Falls
- New York City
- London
- Paris (including Versailles)
- Rome
- Pisa
- Switzerland
- Egypt
- China
- Sydney
- Africa
- The redwood forests of California
- San Francisco
- The Grand Canyon
- Mount Rushmore
- . . . and many more!

# *Special Offerings*

## SWEET ESCAPES

We can't wait to show you the world! We'll get you to the shore, then put you on a bus, boat, train, airplane, helicopter, or unicycle. Remember to use your imagination and have fun. Most cruise ships don't travel to heavily landlocked locales like the Great Wall of China or the Grand Canyon, so consider yourself lucky!

## SCRAPBOOKING AT SEA

Do you want to preserve and treasure your travel memories? Of course you do! But you're only candy, and you'll forget everything if you don't organize your postcards, photographs, and ticket stubs. Why not trap your memories inside a gorgeous travel scrapbook? We'll show you how to get started. Safety scissors provided.

## SPARKLE SPA

Treat yourself to a soothing afternoon at the world-class Sparkle Spa. Recapture lost luster with a soft sugar scrub. Dip into a deep, dark chocolate bath. Your crystals will quiver after a rejuvenating hot rock candy massage. You'll feel as if you've tacked a few years onto your sell-by date!

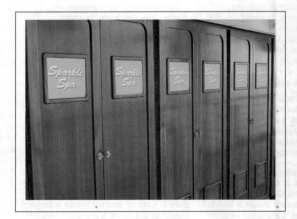

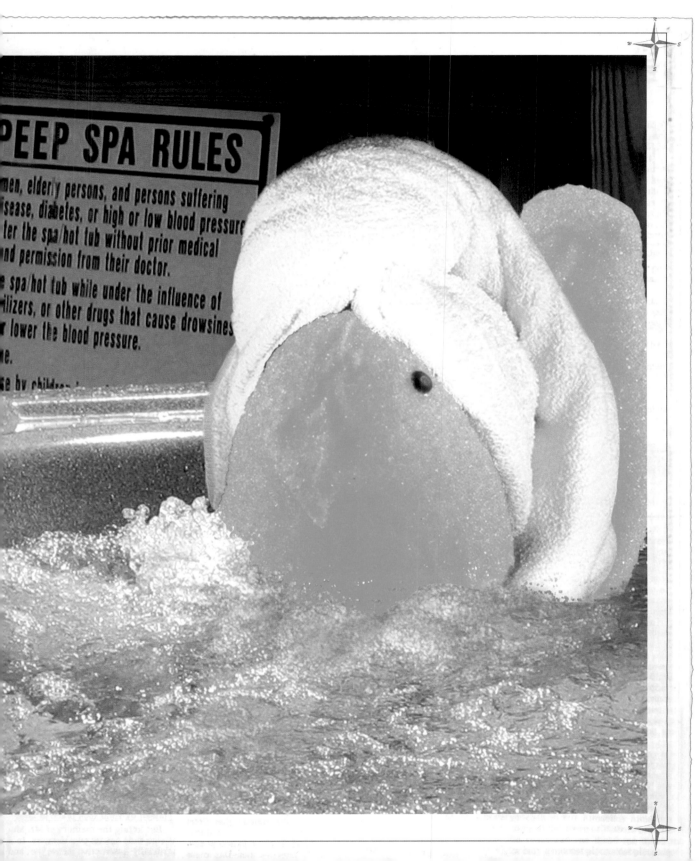

# For Your Enjoyment

## SPORTS

Sports Director Candy Sprinkles tosses a mean gum ball! Can you dodge it? Activities abound on the GooE2, from Sugarpuff shuffleboard to miniature marshmallow golf. There's fun for every candy, no matter your coating, filling, or range of motion.

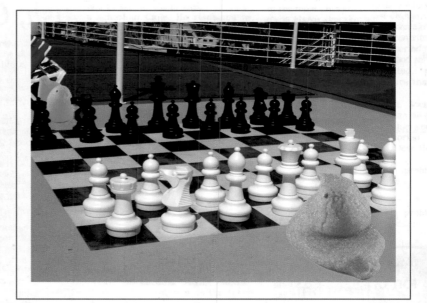

## ENTERTAINMENT

World-class entertainment awaits you aboard the GooE2. Actress and chanteuse Sugar Peeps performs her award-coveting Las Vegas–style revue. (Ask for an autograph—Miss Peeps is contractually obliged to provide one!) If you're in the mood for a laugh, check out candy comedian Emmett T. Bonbon trading bons mots with sidekick Li'l Waffles. And magician Herbert Fudge makes a root beer float disappear every afternoon.

# Our Distinguished Crew

## CAPTAIN JIMBO SPARKLES

GooE2 Cruise Lines Inc. is proud to welcome Captain Jimbo Sparkles. This is Jimbo's first ocean voyage. Actually, he's never been aboard a boat. Don't ask him to help you find the poop deck—he's confused enough already! Once the first mate helps him set the cruise control, Jimbo will have plenty of time to captivate you with scintillating stories of his exploits as a semiprofessional hard-boiled egg bedeviler. Look for him at the captain's table. He'll need your help tying his bib.

## FIRST MATE ERIN MALLORY

First Mate Erin Mallory joins the GooE2 after a three-week course in Marshmallow Maritime Studies at the Peepsville Aquarium. She excels at board games, line dancing, and hammocking. She read her first map last week and understood at least one-third of the crazy symbols, dashes, and notations.

## CRUISE DIRECTOR FLO FREELY

Cruise Director Florence Freely will keep you truly entertained. She's planned a gazillion exciting activities, including pearl diving, horseback riding, and tobogganing. Here's your chance to hone those yodeling skills! Flo hopes you brought a cute costume for the Moonlight Marshmallow Masquerade. It's sure to be the sweetest night of your life, unless we hit a melting icecreamberg and the ship sinks!

## PURSER PENN K. CUSTARD

Lost your luggage? Purser Pennsylvania K. Custard is the Peep you need to peep. He has an advanced degree in Lost and Found Studies from the University of Peepsville. If you lost it on the GooE2, you can bet you'll find it beneath the front desk in Purser Custard's cardboard box. Incidentally, would the owner of the calico cat please come forward? There's not much room left in the box since the arrival of Miss Chomper's kittens.

## DOCTOR JENNIFER CORDUROY

Whether it's a minor meltdown or a major shell fracture, Doctor Jennifer Corduroy has the cure. She'll keep you feeling fresh and fit. While other cruise lines have been plagued by the Sugar Shakes, leaving passengers dizzy and discombobulated, the GooE2 has a perfect health record. Our surfaces are sparkling clean and hygienic. Thanks, Doctor Corduroy!

## PHOTOGRAPHER FAMOUS PYE

Smile! It's photographer Famous Pye, and he'll capture your sweetest memories as they crystallize. World-renowned for his elegant sepia-toned prints of Prince Tony C. Piano Sr., Pye welcomes the challenge of documenting good times aboard the GooE2. Avid scrapbookers will want to stock up on his slick pics. Your travel scrapbook will be a shoo-in for a blue ribbon at the Peepsville County Fair!

## ENTERTAINER SUGAR PEEPS

You loved her in the movies. You copied her celebrity style. You plastered her gorgeous poster inside your gym locker. Well, here she is, folks—the incomparable Miss Sugar Peeps! She's here to entertain you, seven days a week and three shows a day. Don't miss her Las Vegas–style revue in the Peanut Chew Lounge, where she'll be belting out "Row, Row, Row Your Boat" almost nonstop. Wow!

## TEEN DIRECTOR TRAVIS TREAT

You love your teenagers! But sometimes, you wish they were someone else's responsibility. That's why we've hired Teen Director Travis Treat. He's a heap of fun, and he'll introduce your limber limit-testers to exciting sports like bungee jumping, waterfall barreling, and checkbook balancing. Life jackets, goggles, and permission slips required.

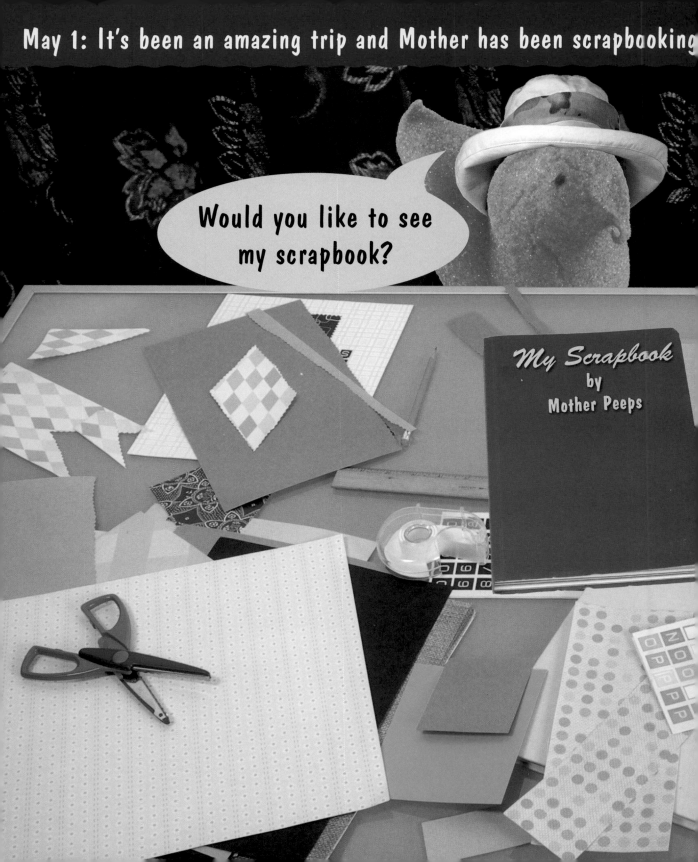

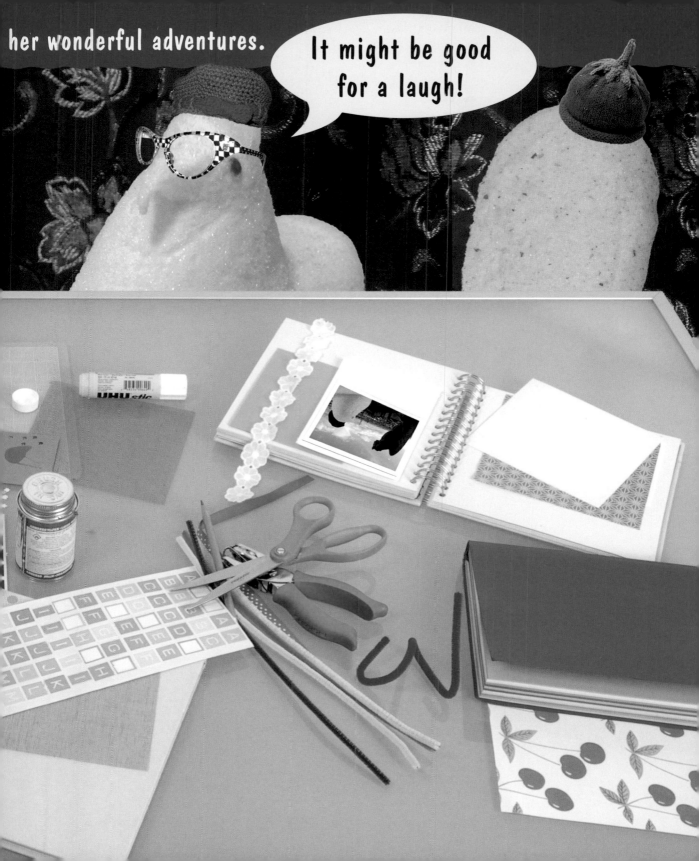

Welcome to my scrapbook.
I hope it wins a prize!
This cruise is lots of **fun**.
I met a half-sour **pickle**,
I met a **rich cream bun**.

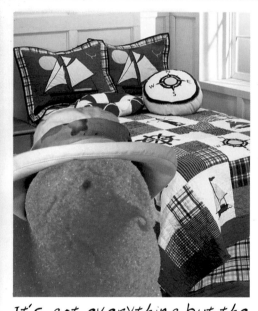

It's got everything but the kitchen sink. Fortunately, I brought one.

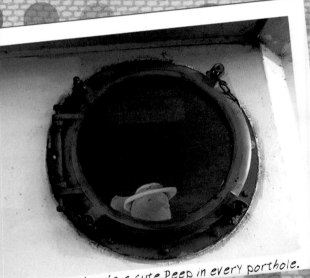

Artsy! There's a cute Peep in every porthole.

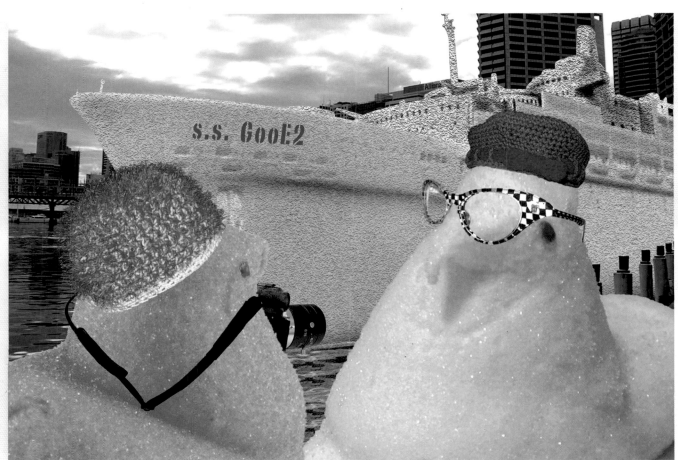

s.s. GooE2

Look at that shine! Poor Madge needed to powder sugar her nose.

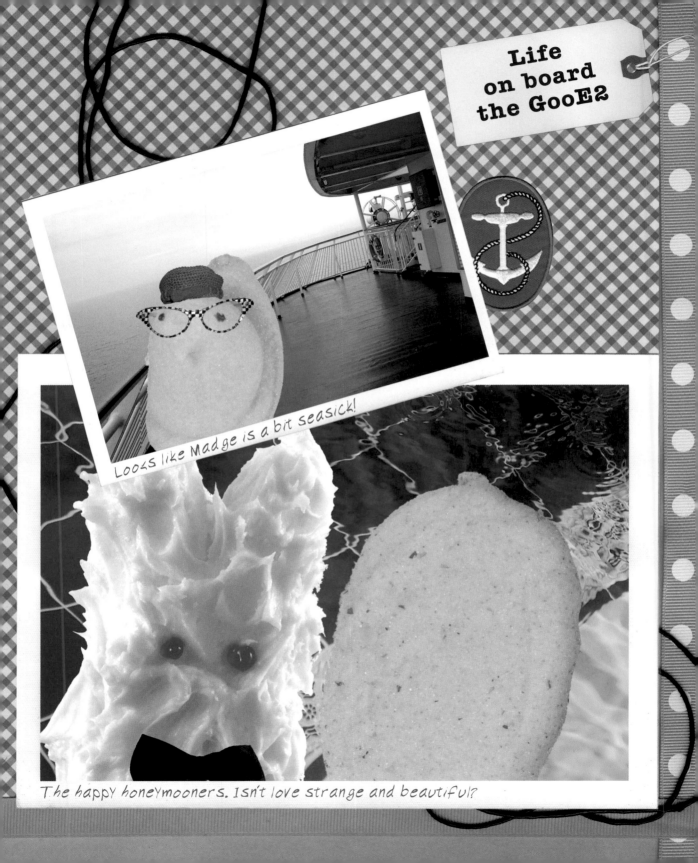

Life
on board
the GooE2

Looks like Madge is a bit seasick!

The happy honeymooners. Isn't love strange and beautiful?

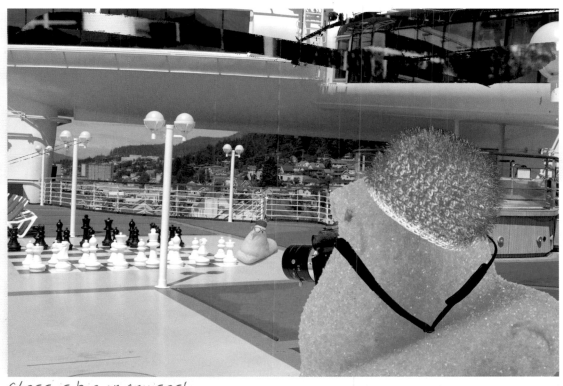

Chess is big on cruises!

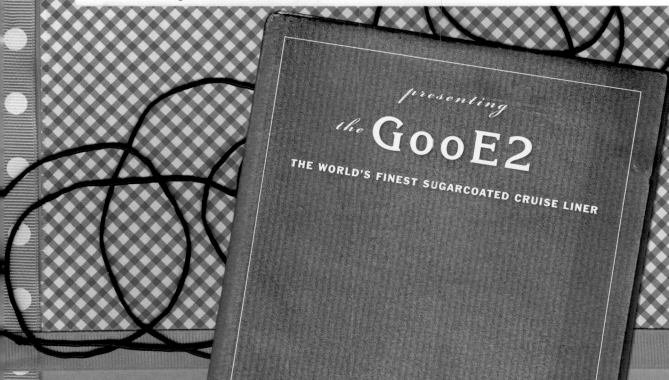

*presenting*

the GooE2

**THE WORLD'S FINEST SUGARCOATED CRUISE LINER**

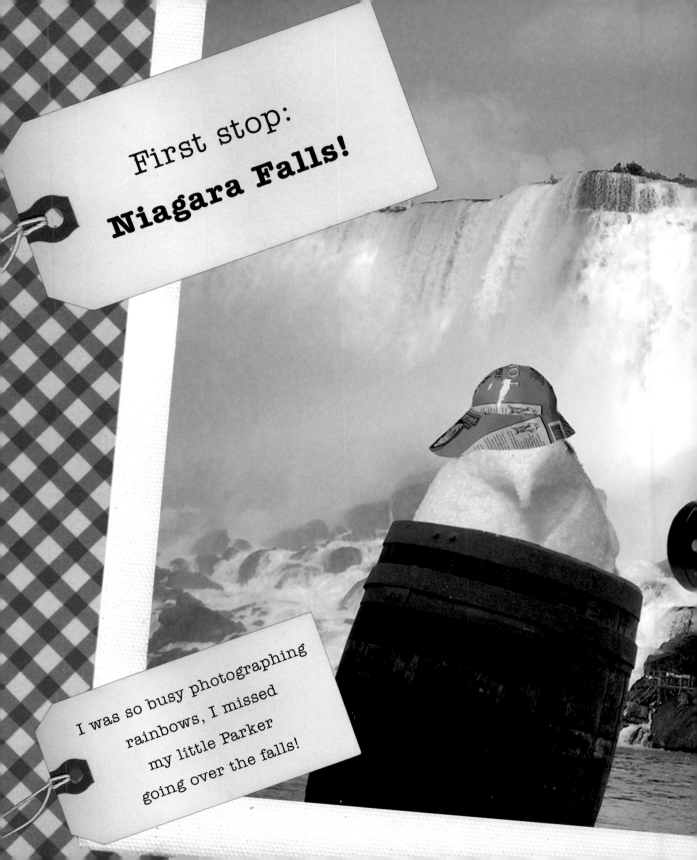

First stop:
**Niagara Falls!**

I was so busy photographing rainbows, I missed my little Parker going over the falls!

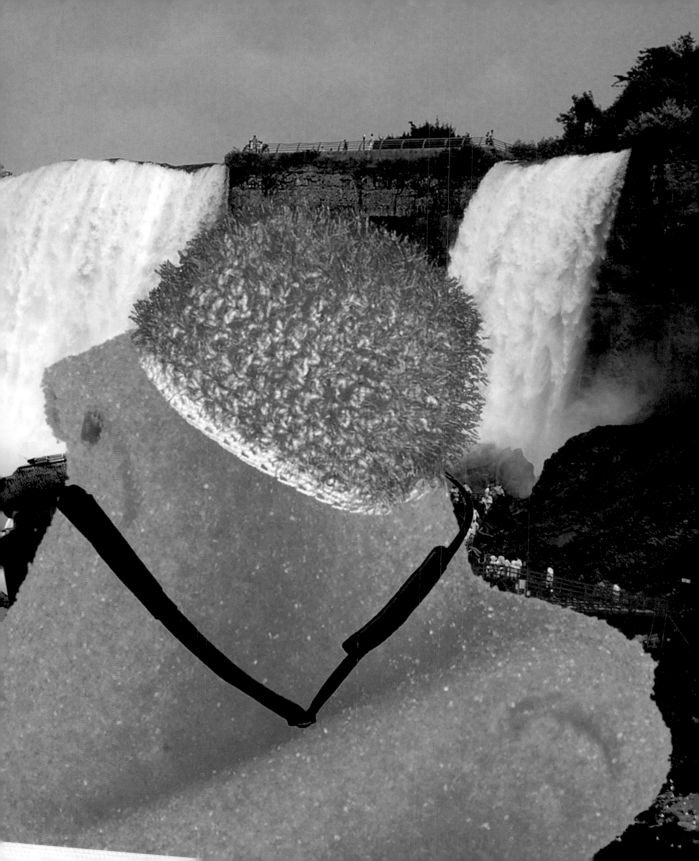

Sub

PEEPS 1 2 3 7

New York City, Times Square

Oh buoy! New York, here we come!

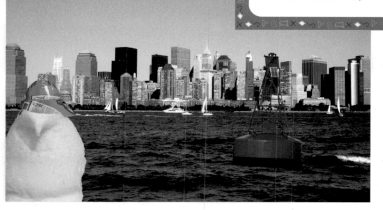

A carriage ride in Central Park

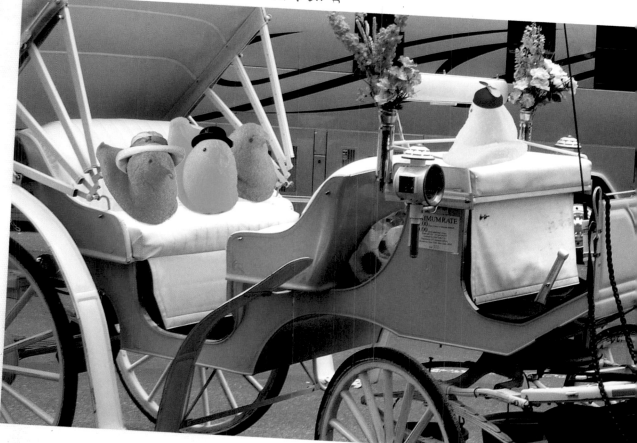

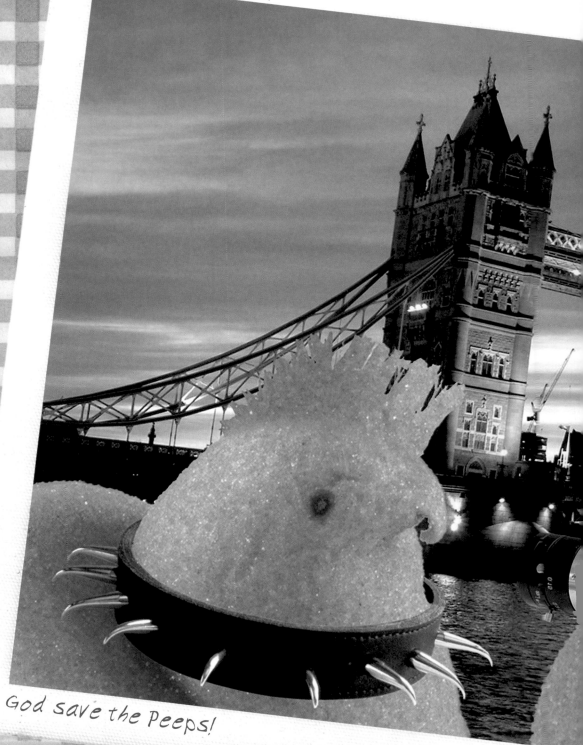

# LONDON

God save the Peeps!

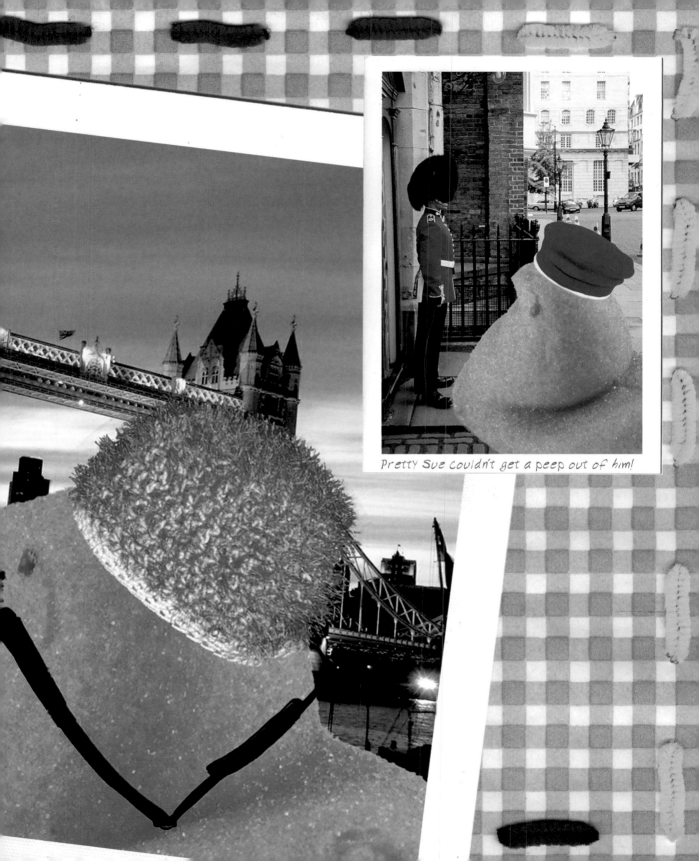

Pretty Sue couldn't get a peep out of him!

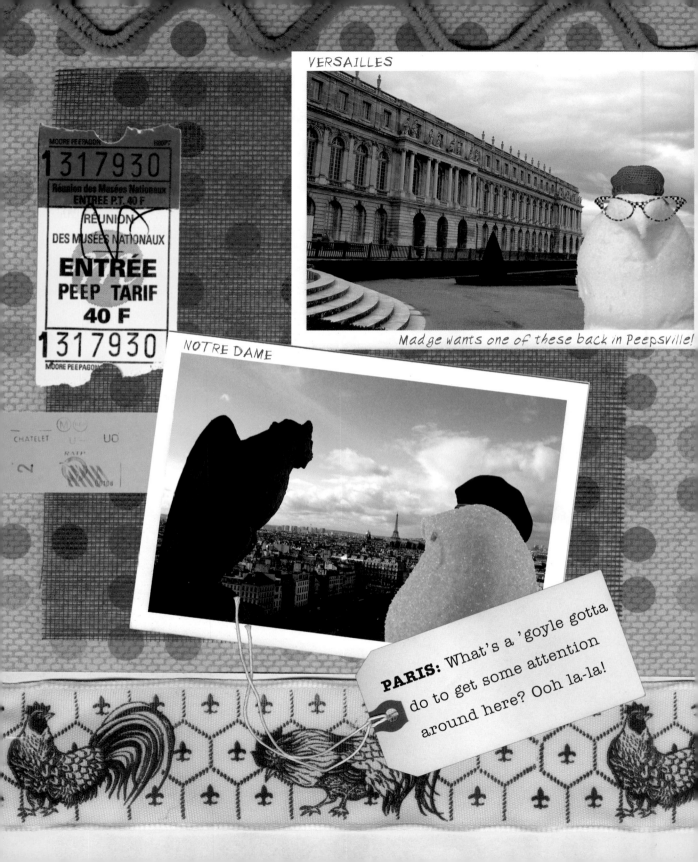

VERSAILLES

*Madge wants one of these back in Peepsville!*

NOTRE DAME

**PARIS:** What's a 'goyle gotta do to get some attention around here? Ooh la-la!

MOORE PEEPAGON

**1 3 1 7 9 3 0**

Réunion des Musées Nationaux
ENTRÉE P.T. 40 F

RÉUNION
DES MUSÉES NATIONAUX

**ENTRÉE**
**PEEP TARIF**
**40 F**

**1 3 1 7 9 3 0**

MOORE PEEPAGON

CHATELET
2
RATP

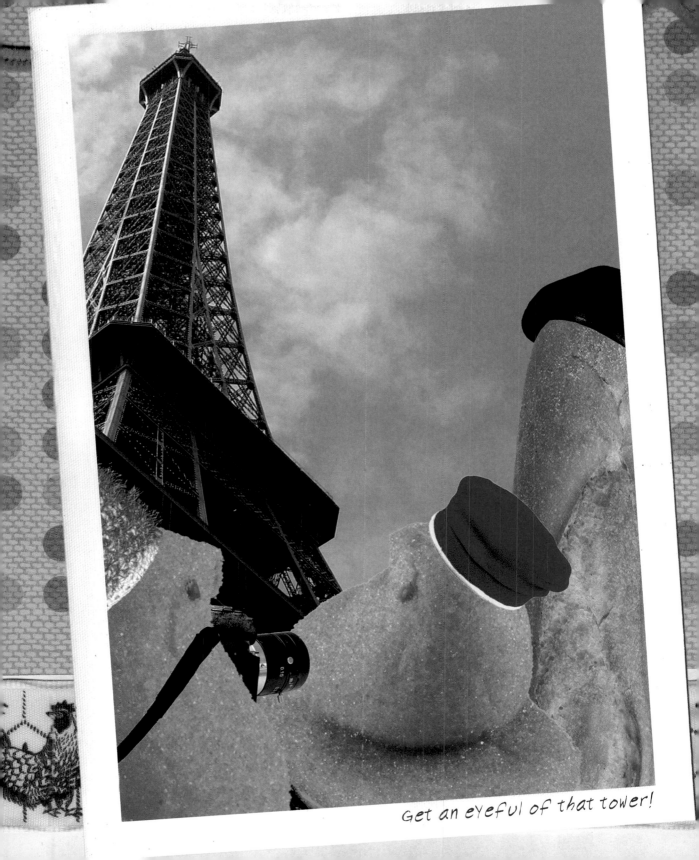

Get an eyeful of that tower!

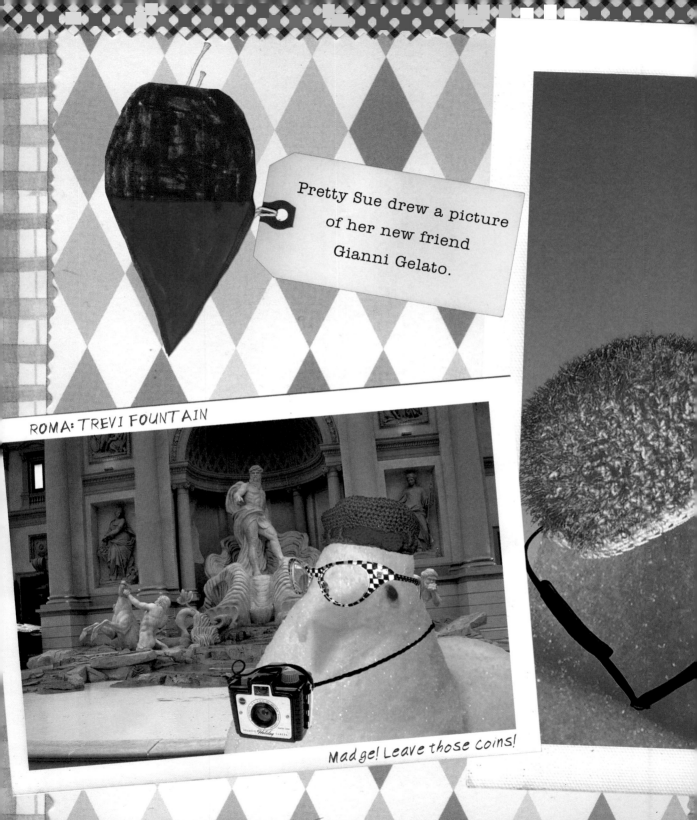

Pretty Sue drew a picture of her new friend Gianni Gelato.

ROMA: TREVI FOUNTAIN

Madge! Leave those coins!

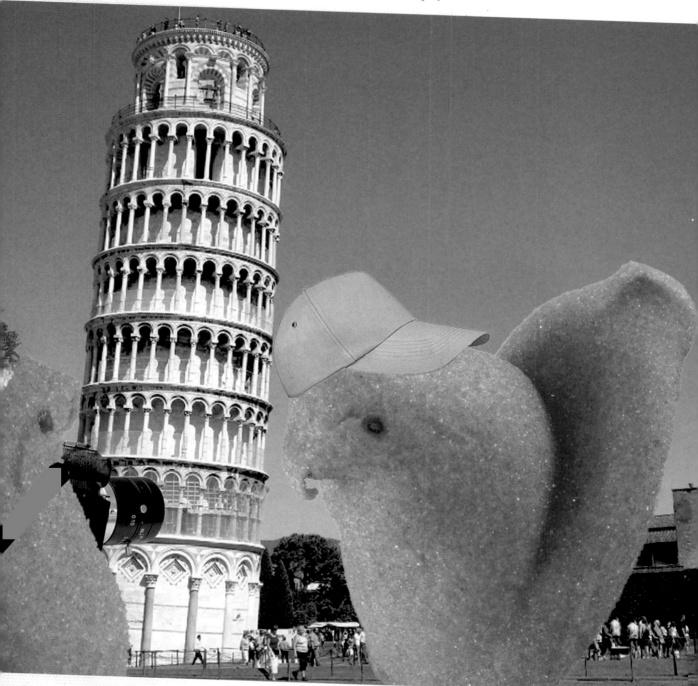

# THE LEANING TOWER OF PISA

This tower weighs a TON!

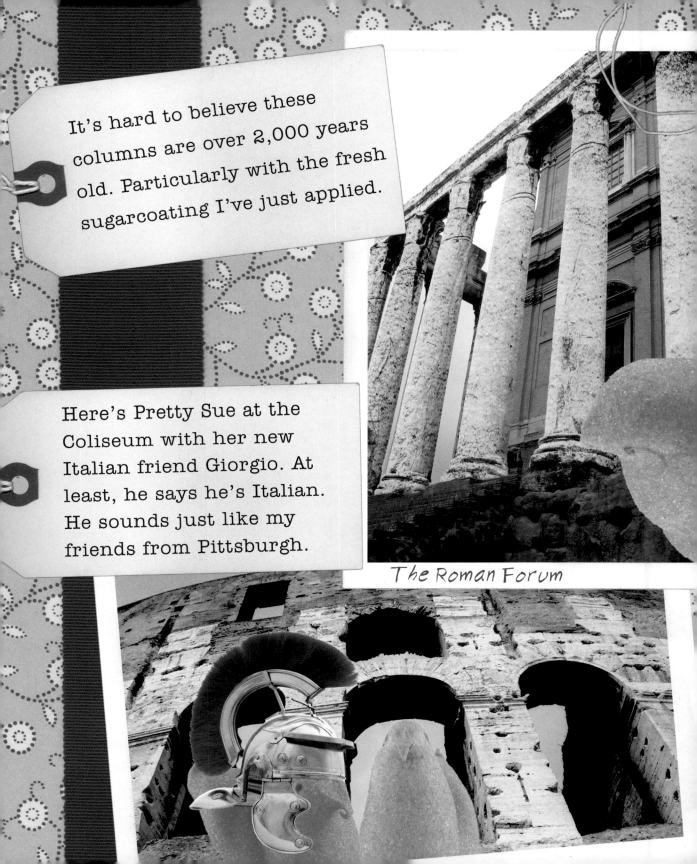

It's hard to believe these columns are over 2,000 years old. Particularly with the fresh sugarcoating I've just applied.

Here's Pretty Sue at the Coliseum with her new Italian friend Giorgio. At least, he says he's Italian. He sounds just like my friends from Pittsburgh.

The Roman Forum

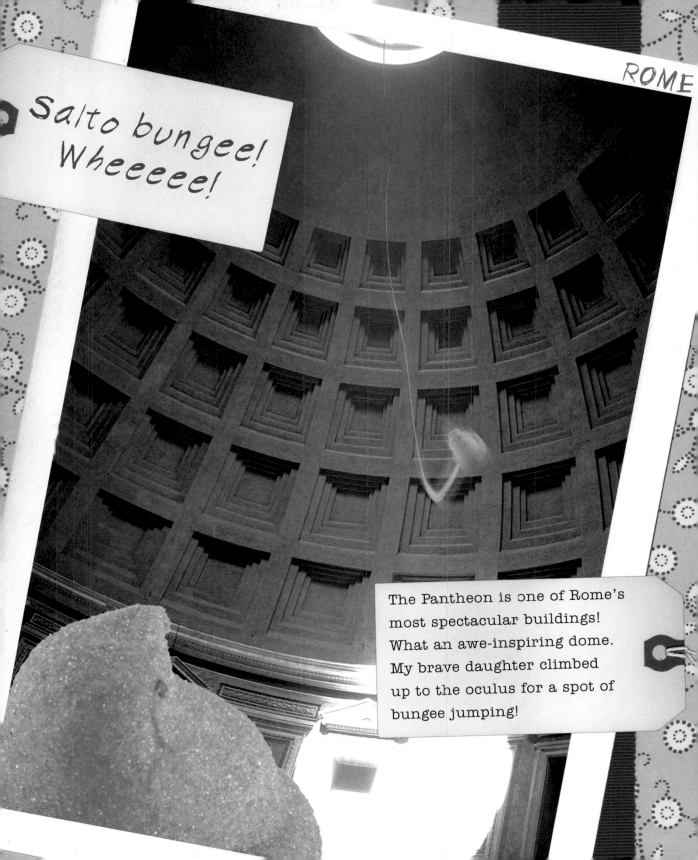

SWISS ALPS

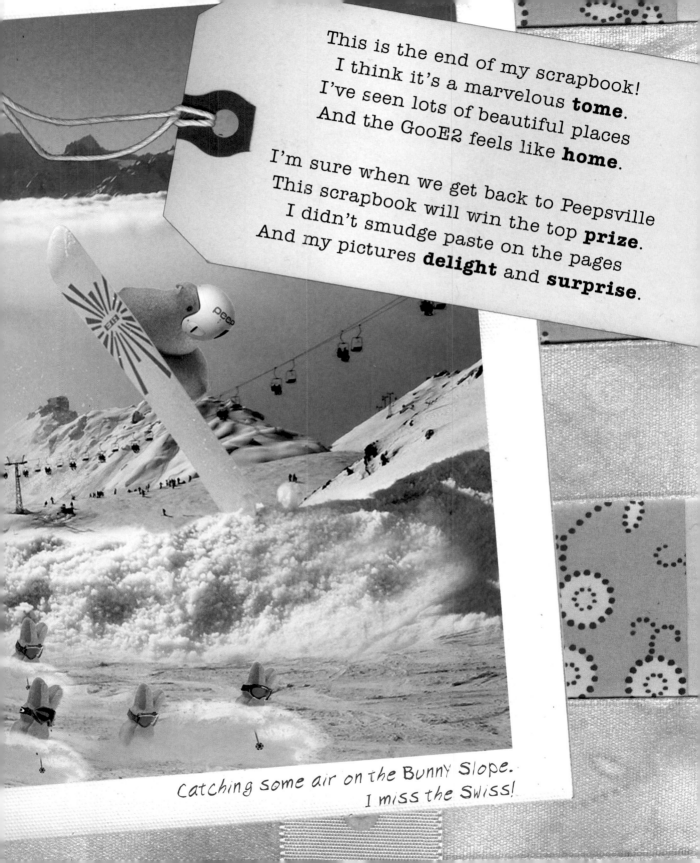

This is the end of my scrapbook!
I think it's a marvelous **tome**.
I've seen lots of beautiful places
And the GooE2 feels like **home**.

I'm sure when we get back to Peepsville
This scrapbook will win the top **prize**.
I didn't smudge paste on the pages
And my pictures **delight** and **surprise**.

Catching some air on the Bunny Slope.
I miss the Swiss!

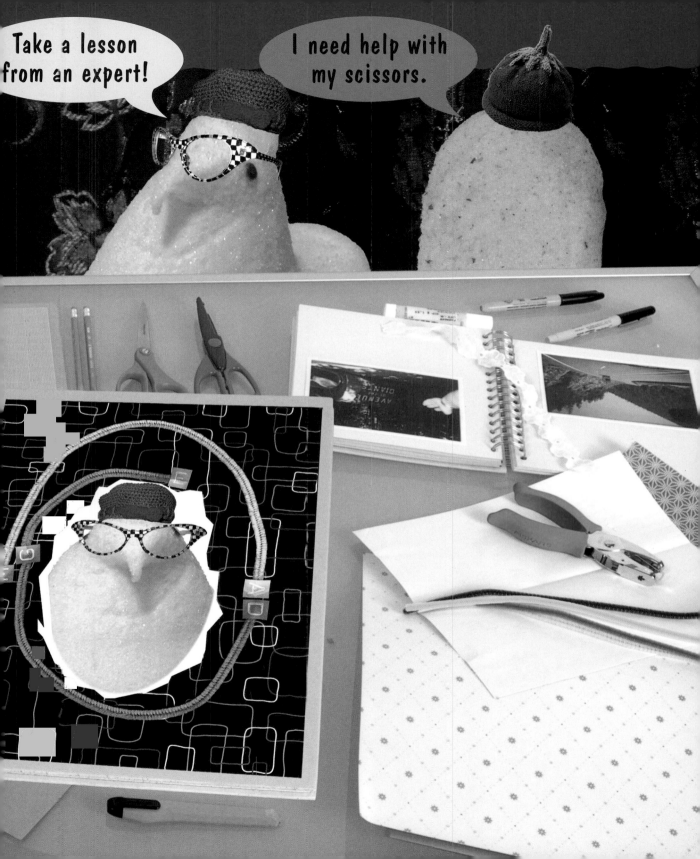

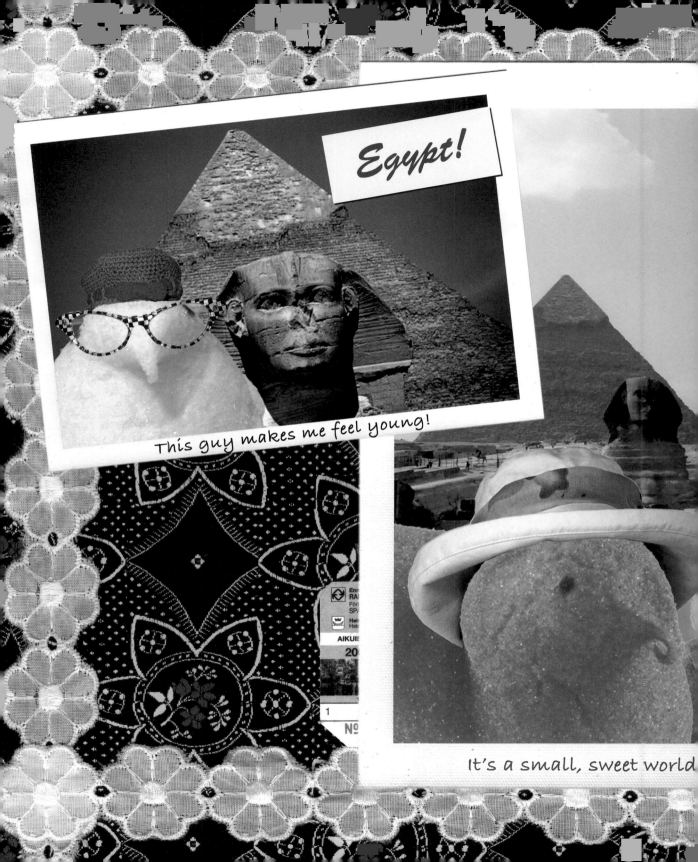

Egypt!

This guy makes me feel young!

It's a small, sweet world

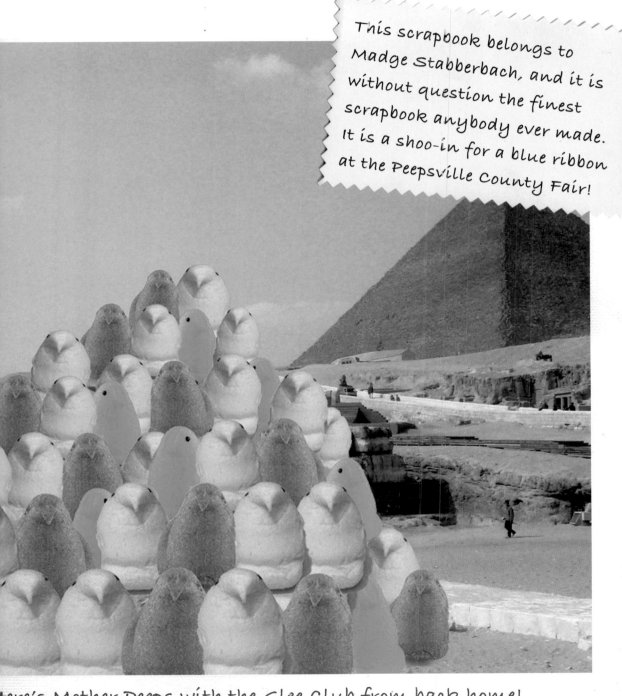

This scrapbook belongs to Madge Stabberbach, and it is without question the finest scrapbook anybody ever made. It is a shoo-in for a blue ribbon at the Peepsville County Fair!

Here's Mother Peeps with the Glee Club from back home!

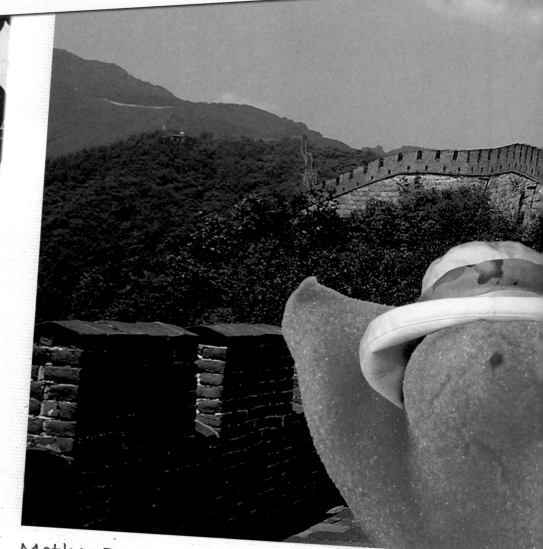

# The Great Wall

Mother Peeps and Pretty Sue at the Great Wall

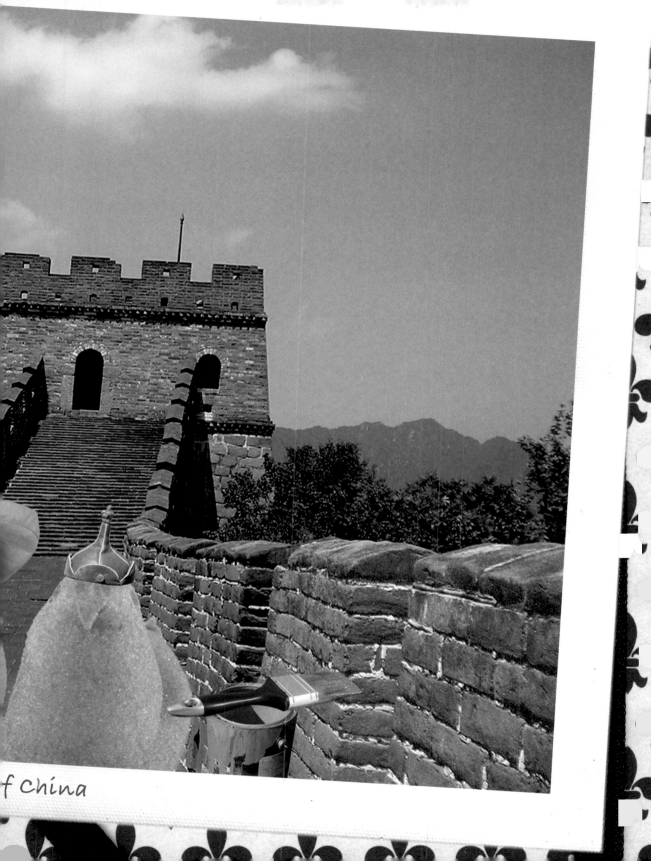

f China

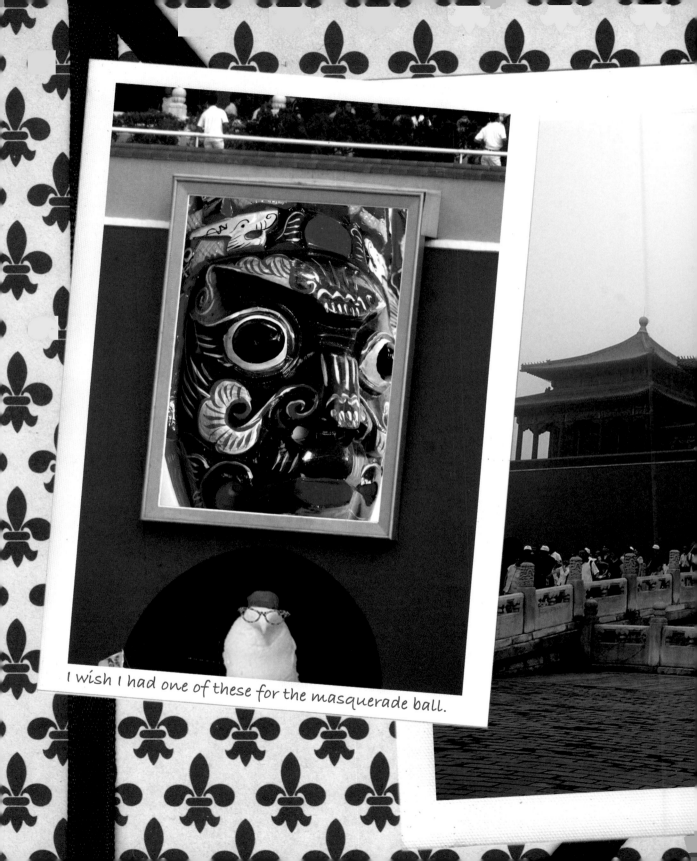

I wish I had one of these for the masquerade ball.

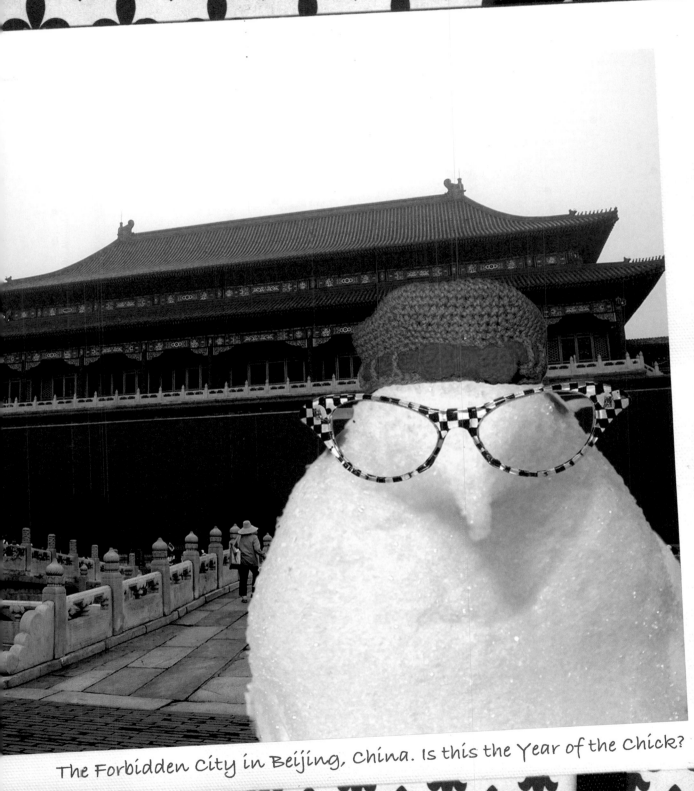

The Forbidden City in Beijing, China. Is this the Year of the Chick?

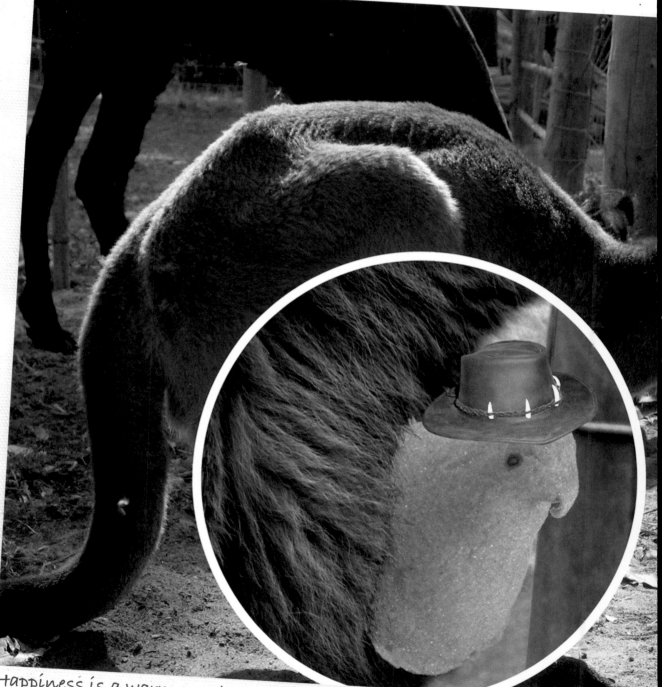

Happiness is a warm pouch! Pretty Sue takes a joyride.

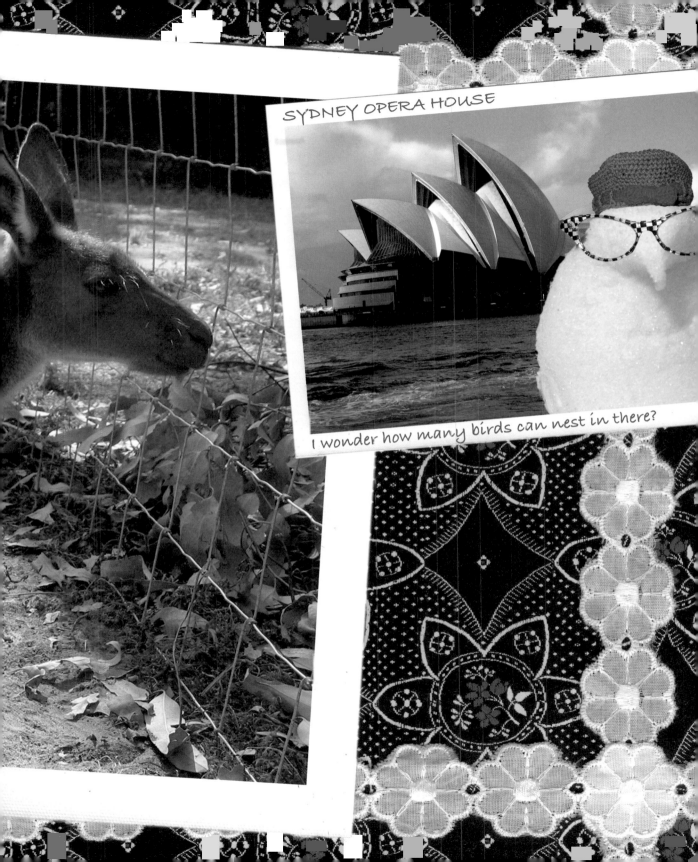

SYDNEY OPERA HOUSE

I wonder how many birds can nest in there?

# Tanzania

Mother Peeps takes a picture of her long

ost cousins!

I wish they all

*California*

REDWOOD FOREST

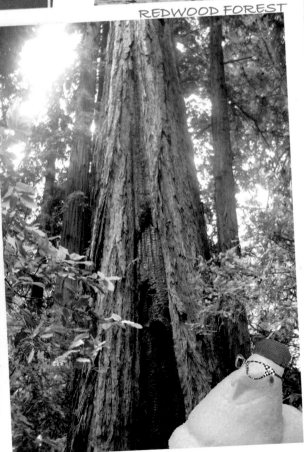

I was speechless, for once.

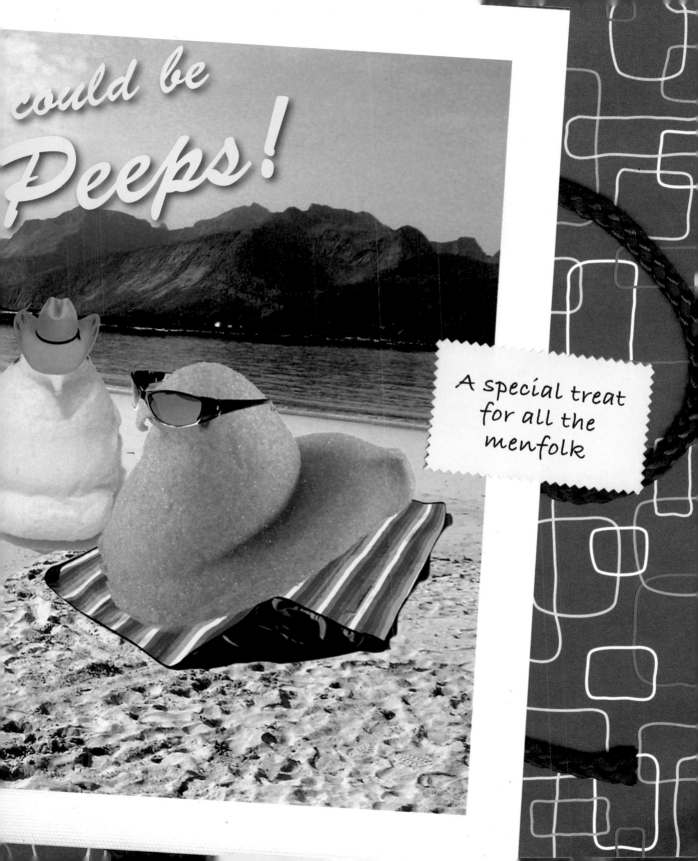

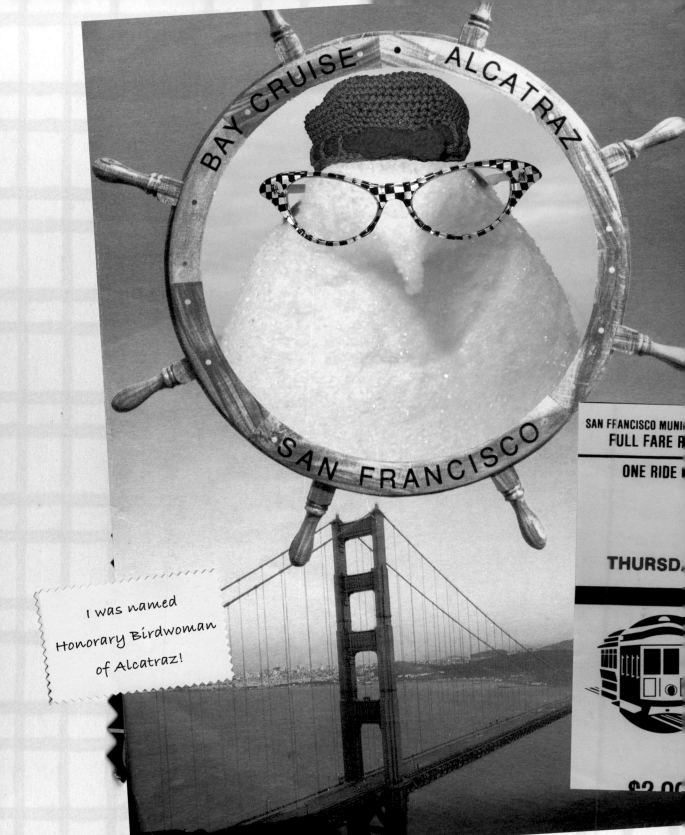

BAY CRUISE • ALCATRAZ

SAN FRANCISCO

SAN FRANCISCO MUNI
FULL FARE R

ONE RIDE

THURSDA

$2.00

I was named
Honorary Birdwoman
of Alcatraz!

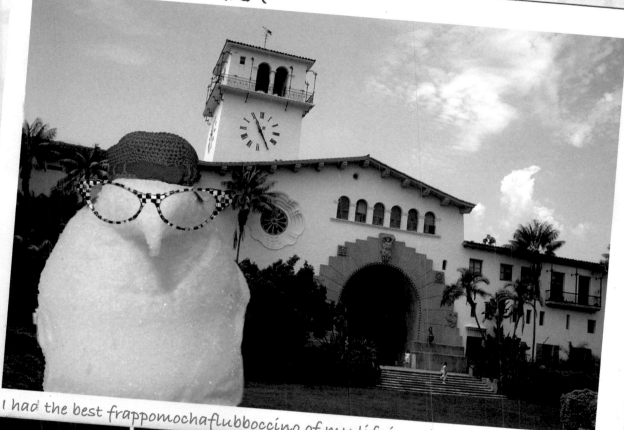

# SANTA BARBARA

I had the best frappomochaflubboccino of my life in this town!

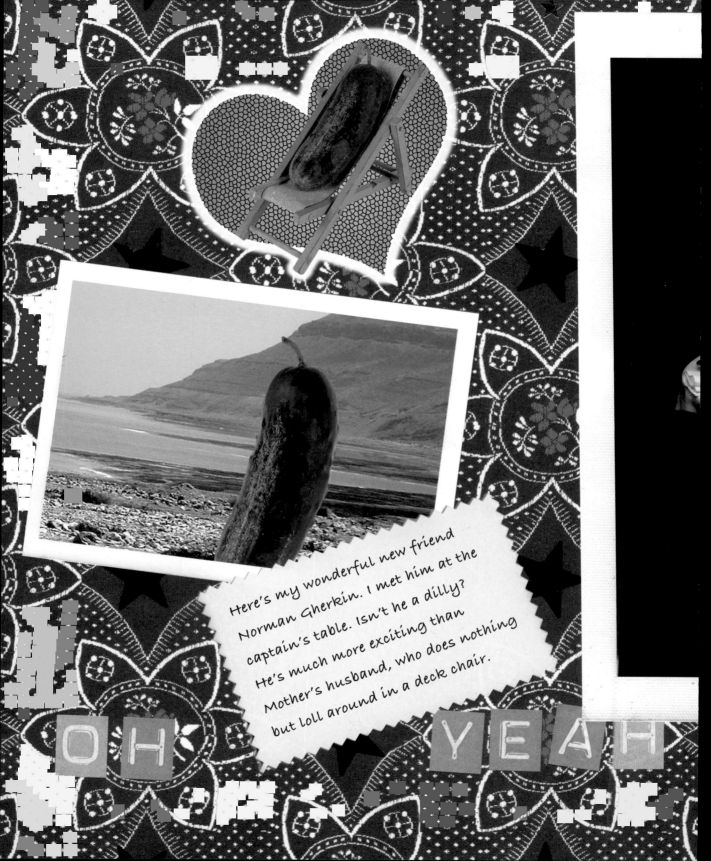

Here's my wonderful new friend Norman Gherkin. I met him at the captain's table. Isn't he a dilly? He's much more exciting than Mother's husband, who does nothing but loll around in a deck chair.

OH YEAH

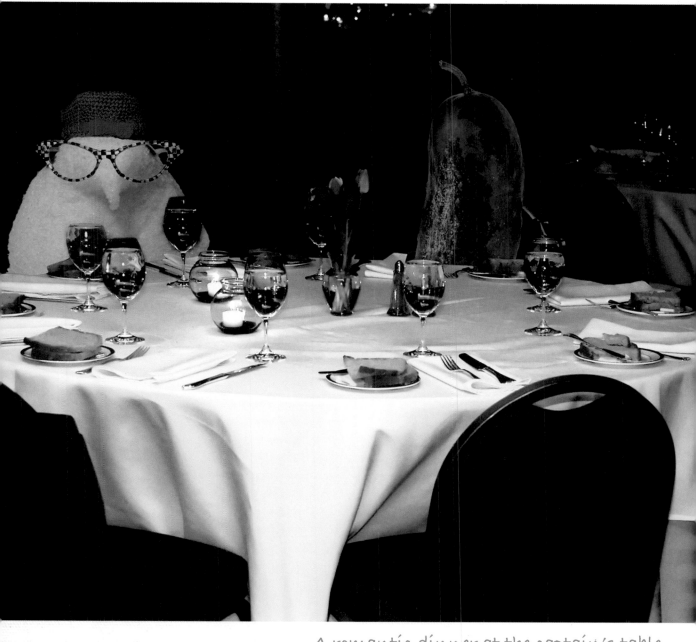

A romantic dinner at the captain's table

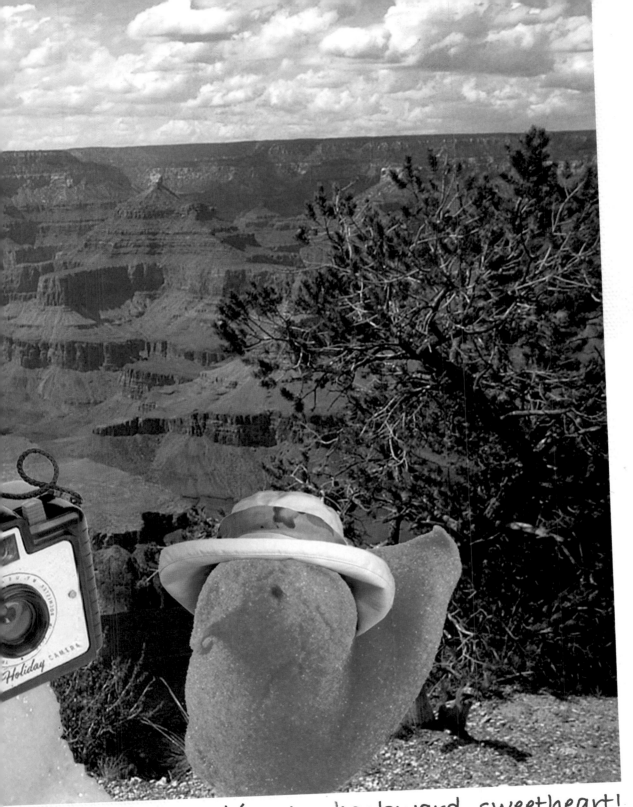

. . . One more big step backward, sweetheart!

What a tasteful monument.

GOOD TIMES

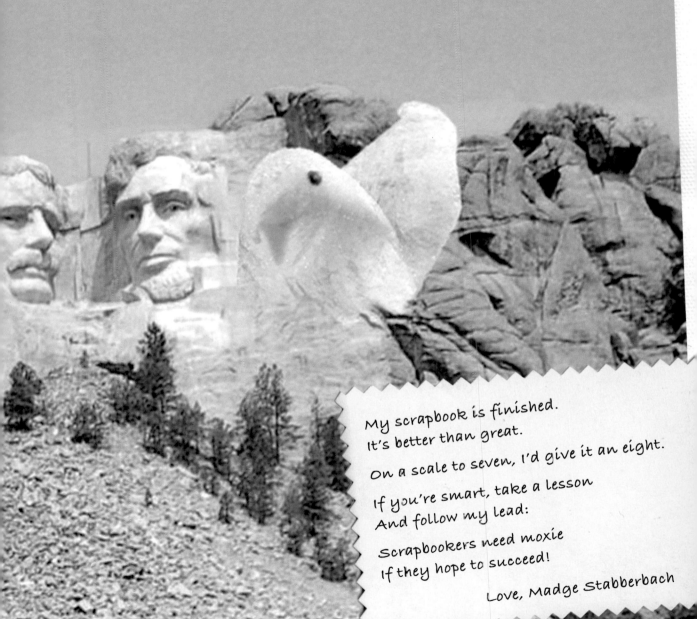

# Mt. Rushmore

My scrapbook is finished.
It's better than great.

On a scale to seven, I'd give it an eight.

If you're smart, take a lesson
And follow my lead:

Scrapbookers need moxie
If they hope to succeed!

Love, Madge Stabberbach

*Captain Jimbo Sparkles*
*cordially requests the pleasure*
*of your company*
*at the*

*Moonlight Marshmallow Masquerade*

*in the Candy Crystal Ballroom*
*on Wednesday, July 2, 2008*
*at 6:27 p.m.*

*RSVP to Cruise Director*
*Florence Freely.*

*Please wear a mask*
*to disguise your unique individuality.*

*No scary costumes will be permitted.*

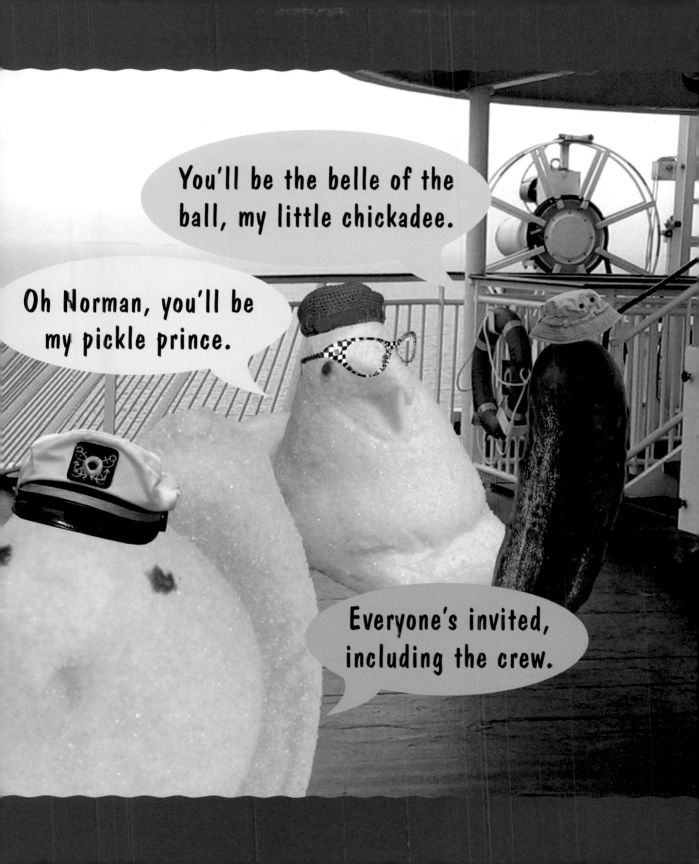

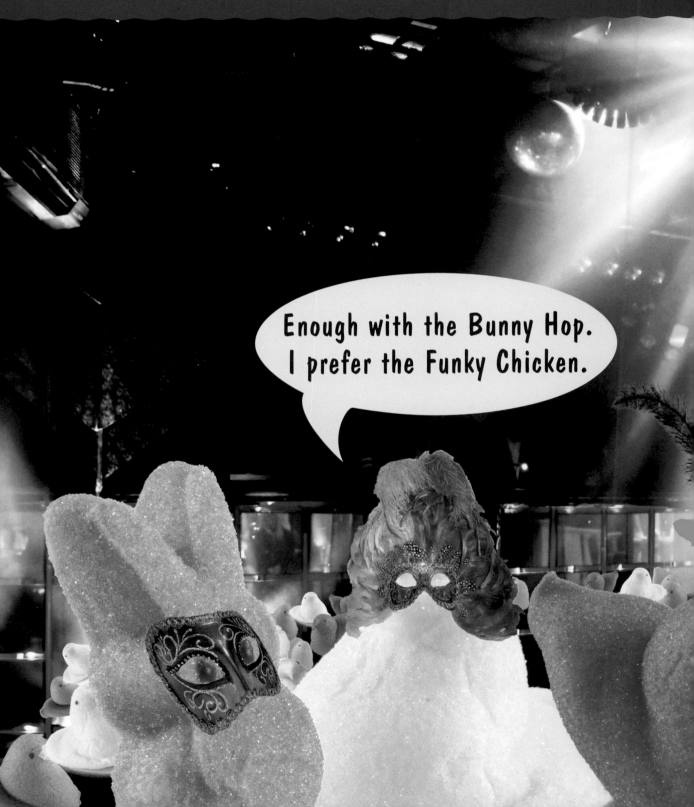

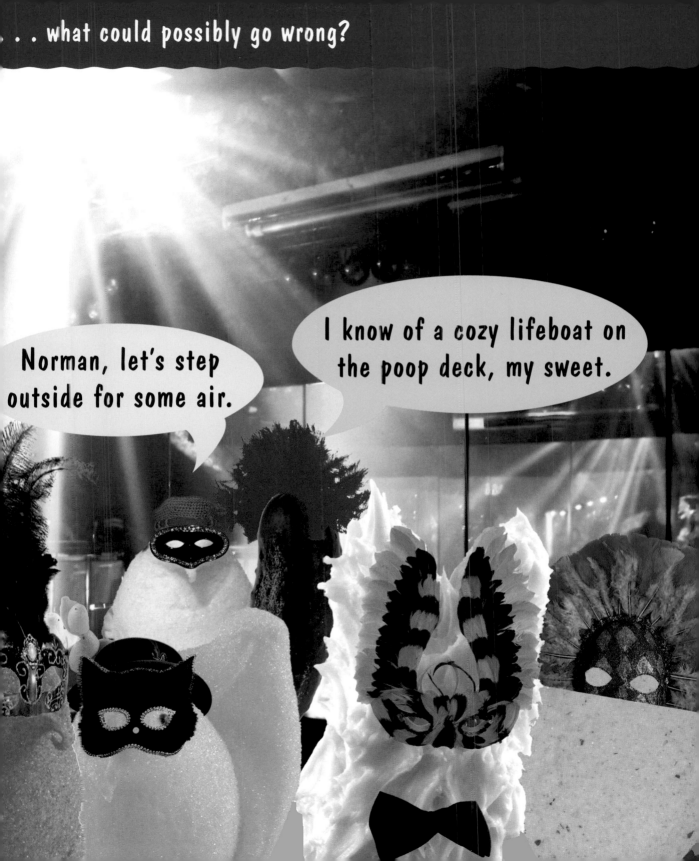

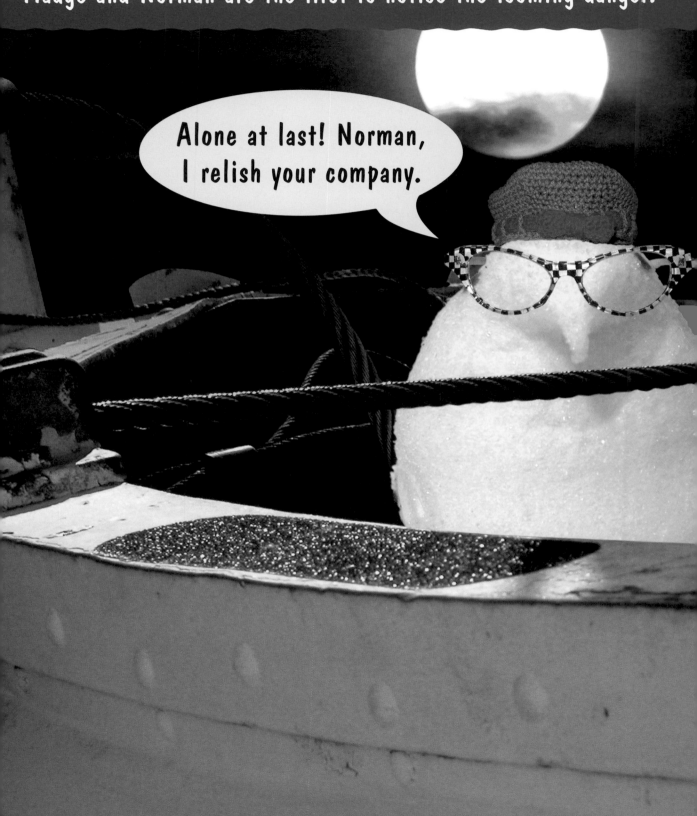

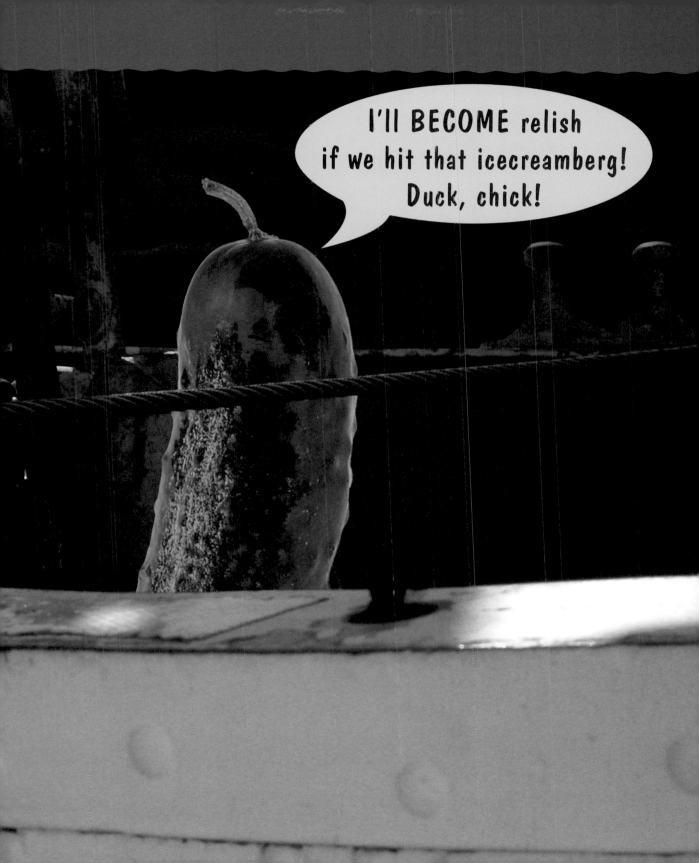

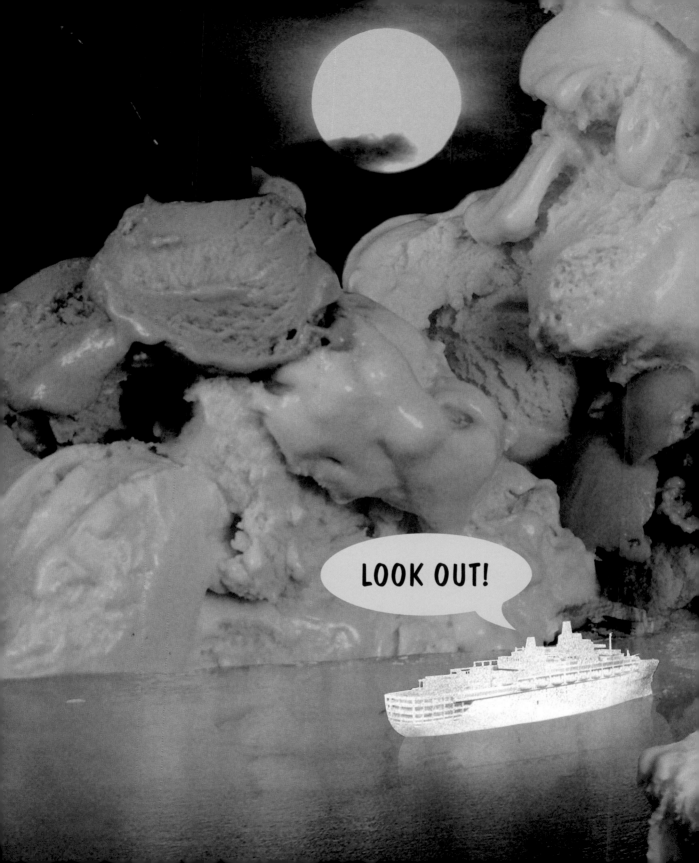

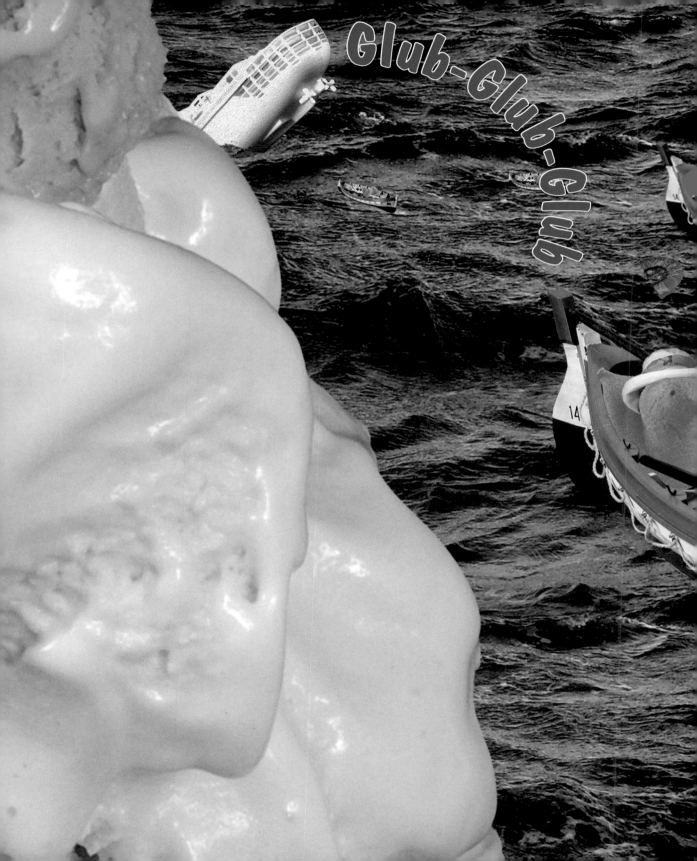

Glub-Glub-Glub

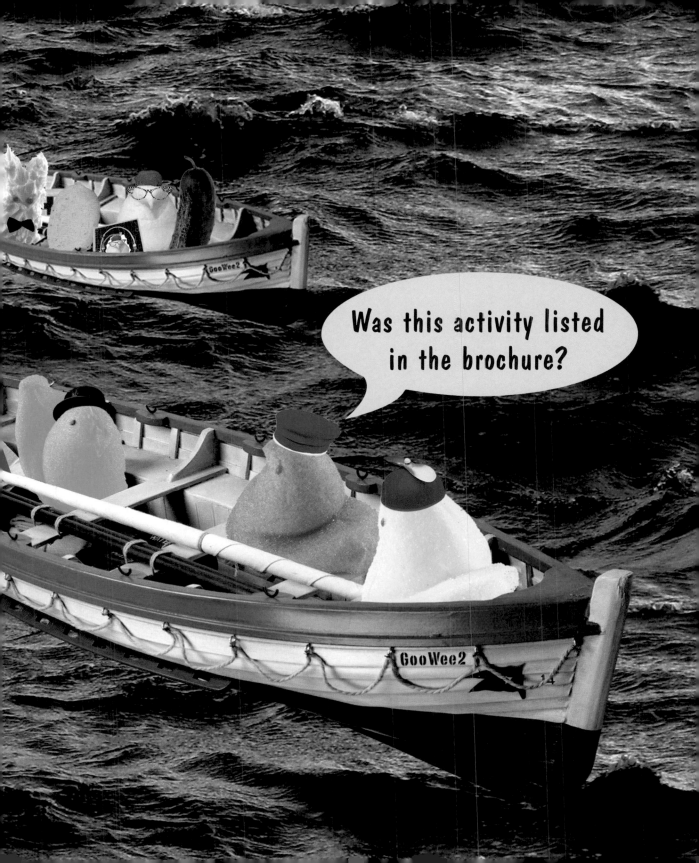

# The Peeps

VOL. XXVI...NO. 68,342     PEEPSVILLE

# GooE2 Sinks!

## *All Passengers Rescued; Peeps Family Will Row, Row, Row Their Lifeboat Gently Home*

PEEPSVILLE — The celebrated cruise liner GooE2 struck an icecreamberg last night and promptly sank. All passengers escaped in lifeboats and were rescued by the Candy Coast Guard.

Captain Jimbo Sparkles and the ship's crew were dancing the Macarena when the accident occurred. "You should have seen us on the dance floor," said Captain Sparkles. "We were terrific!"

"My friend Norman spotted the icecreamberg," said passenger Madge Stabberbach. "We directed everybody into lifeboats and passed out ice-cream spoons. No one went hungry as we waited to be rescued."

"I ate so much ice cream, I've become sweet and sour," said Norman Gherkin.

Prizewinner Mother Peeps and her family declined to board the Candy Coast Guard vessel.

"We're still on vacation," said Mrs. Peeps. "We're going to use this time to enjoy one another's company. If we get bored, we'll flip through the pages of my spellbinding scrapbook. I never travel without my scrapbook. One should always have something sensational to read in a lifeboat. See you back in Peepsville, in time for the county fair."

# oille Currant

*"raisin' your awareness."*

THURSDAY, JULY 3, 2008

SIXTY-TWO CENTS

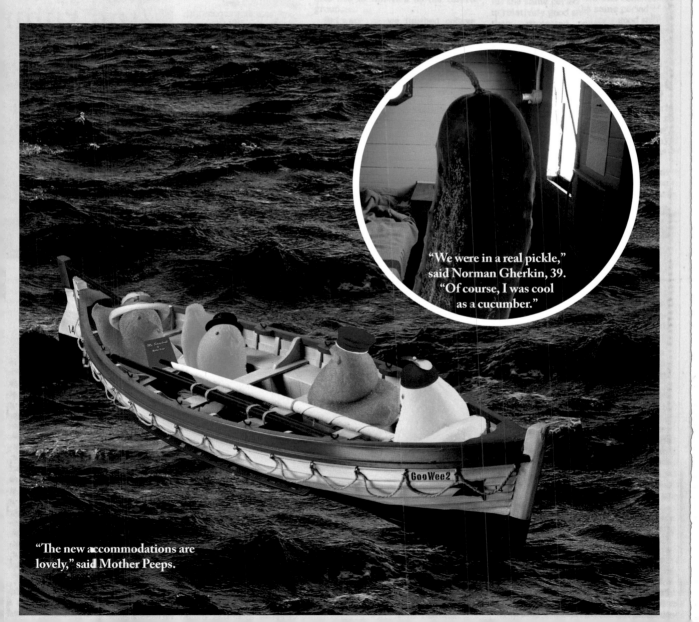

"We were in a real pickle," said Norman Gherkin, 39. "Of course, I was cool as a cucumber."

"The new accommodations are lovely," said Mother Peeps.

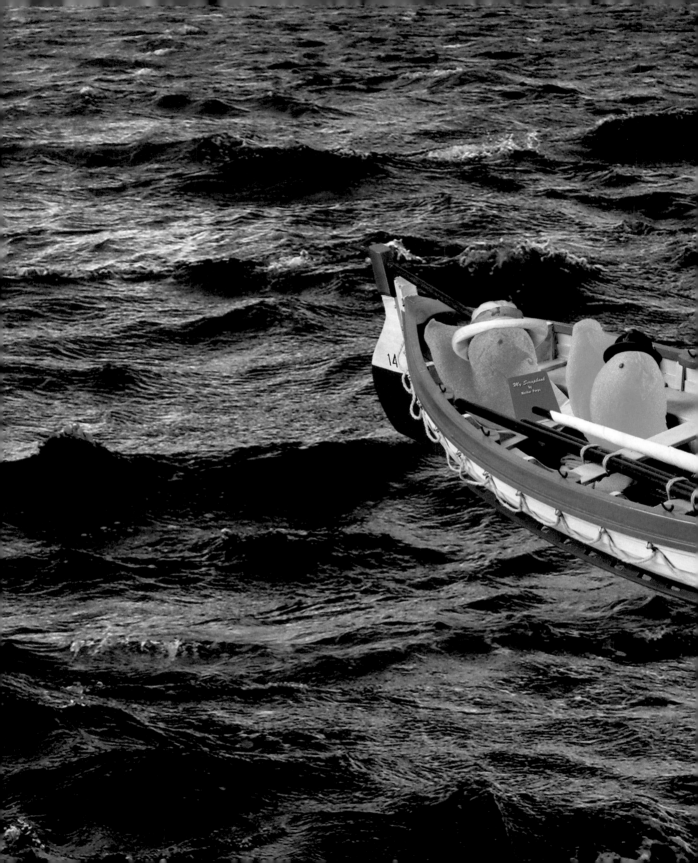

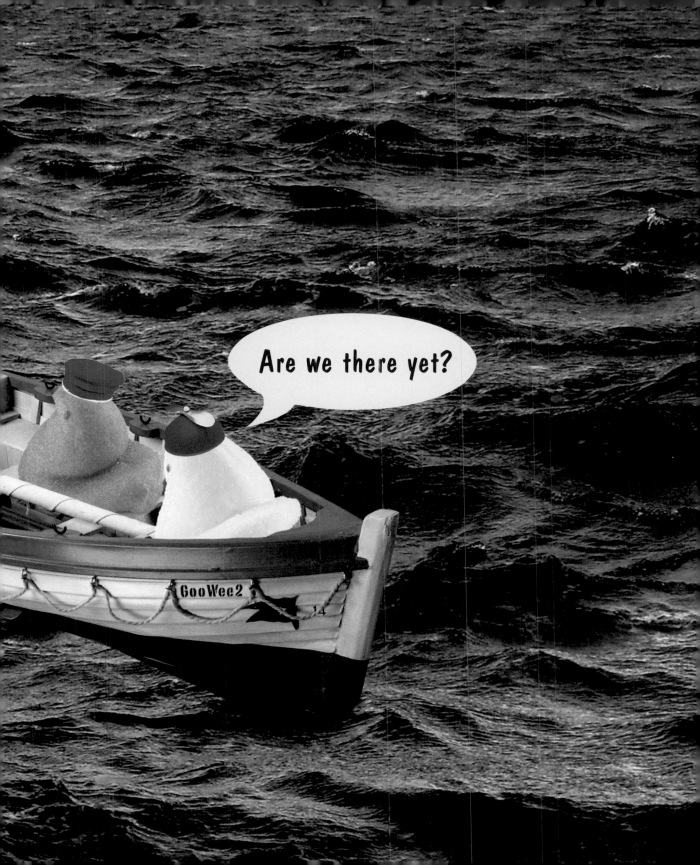

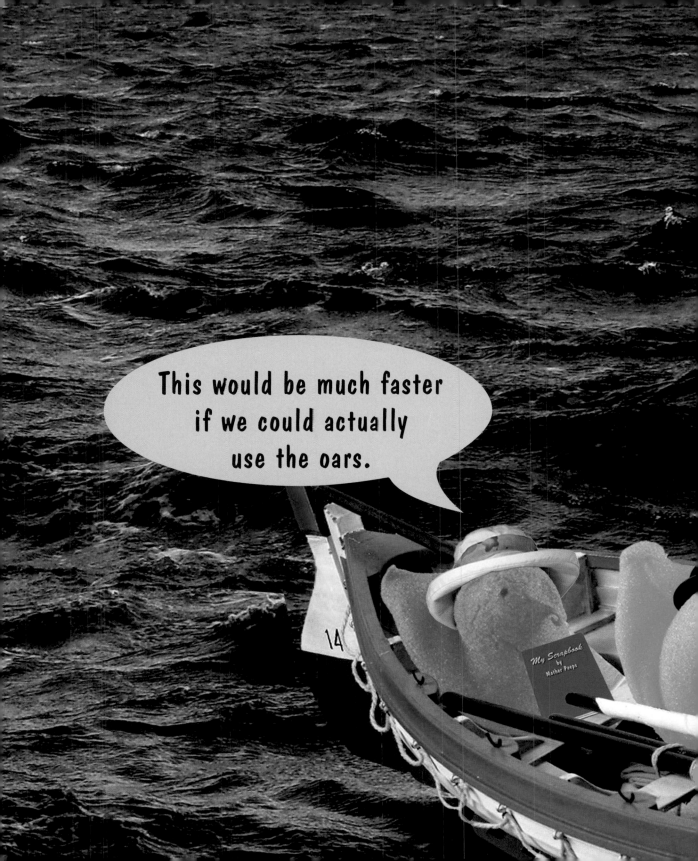

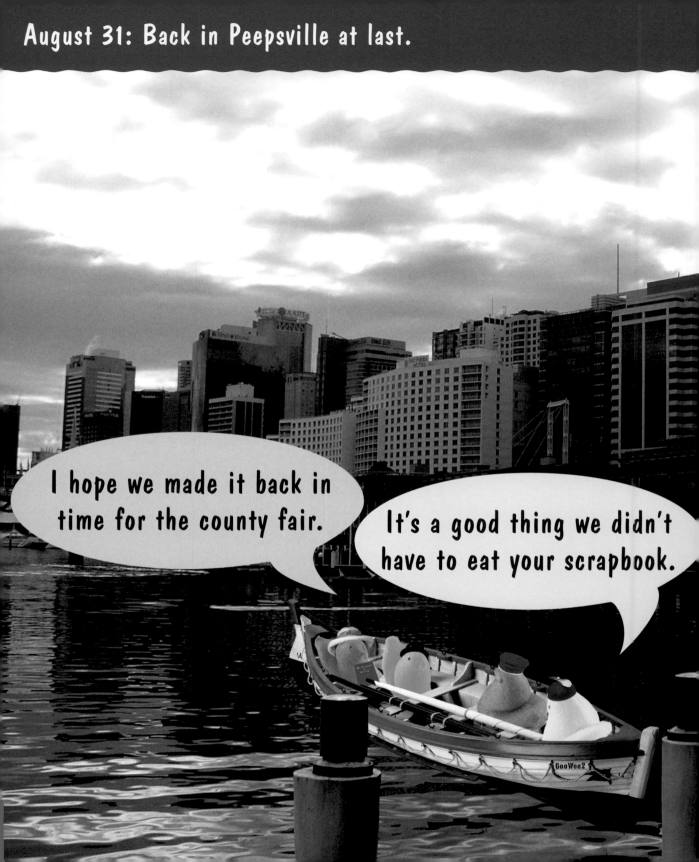

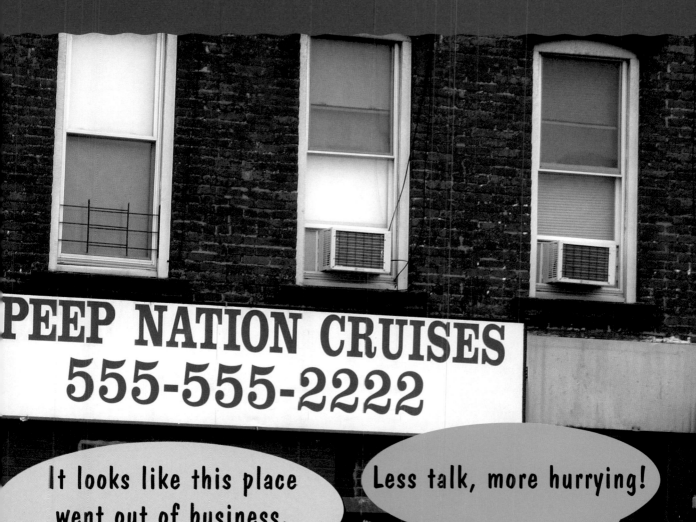

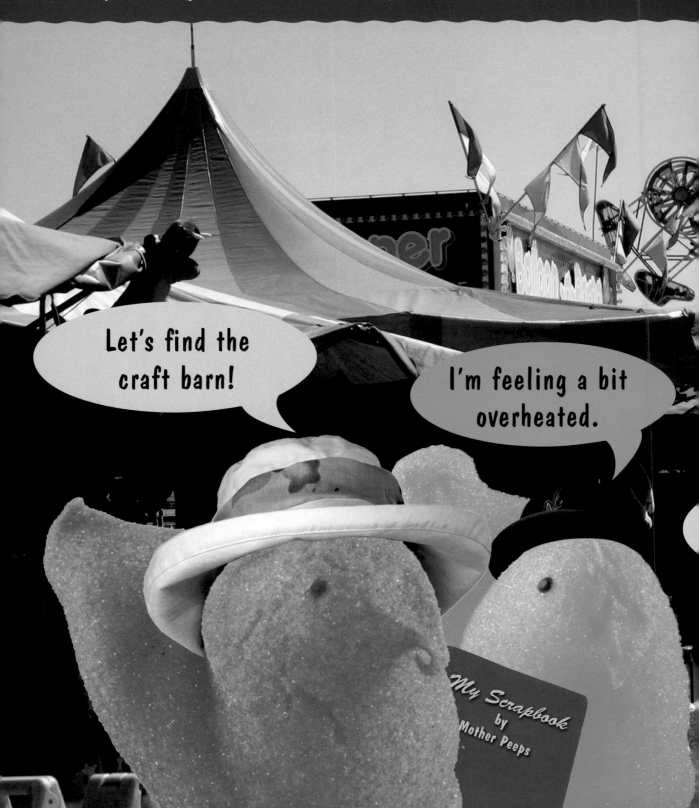

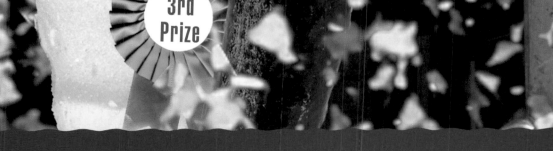

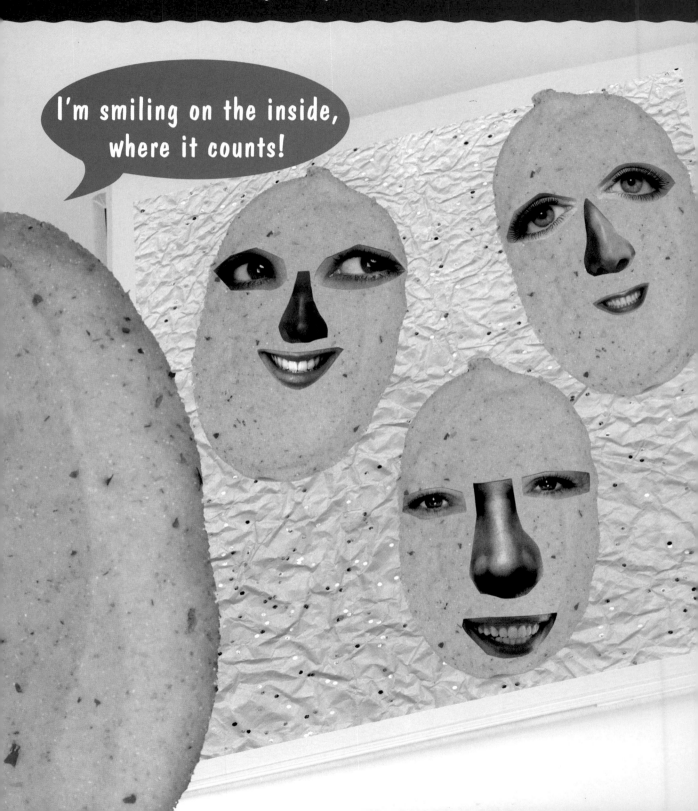

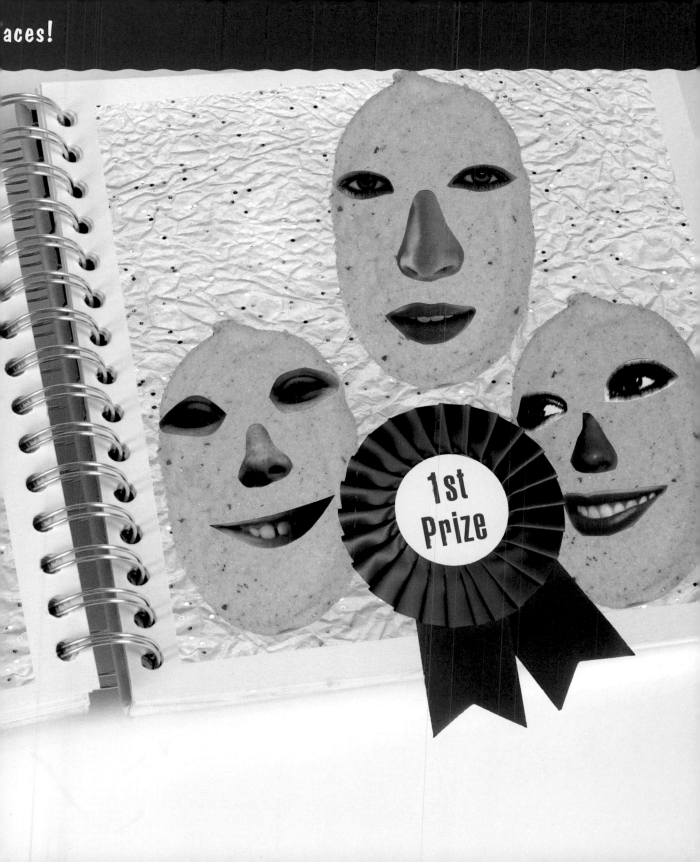

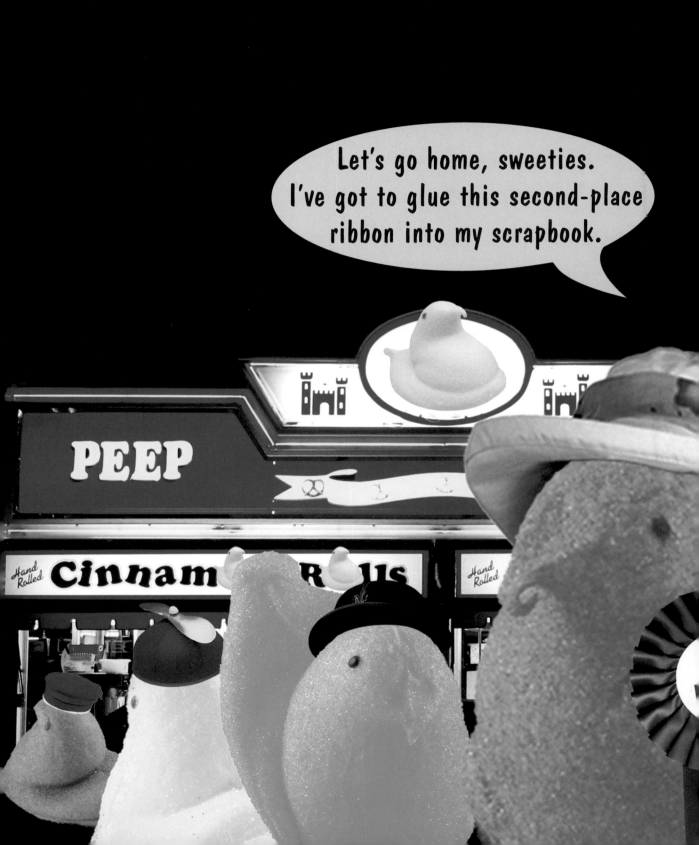

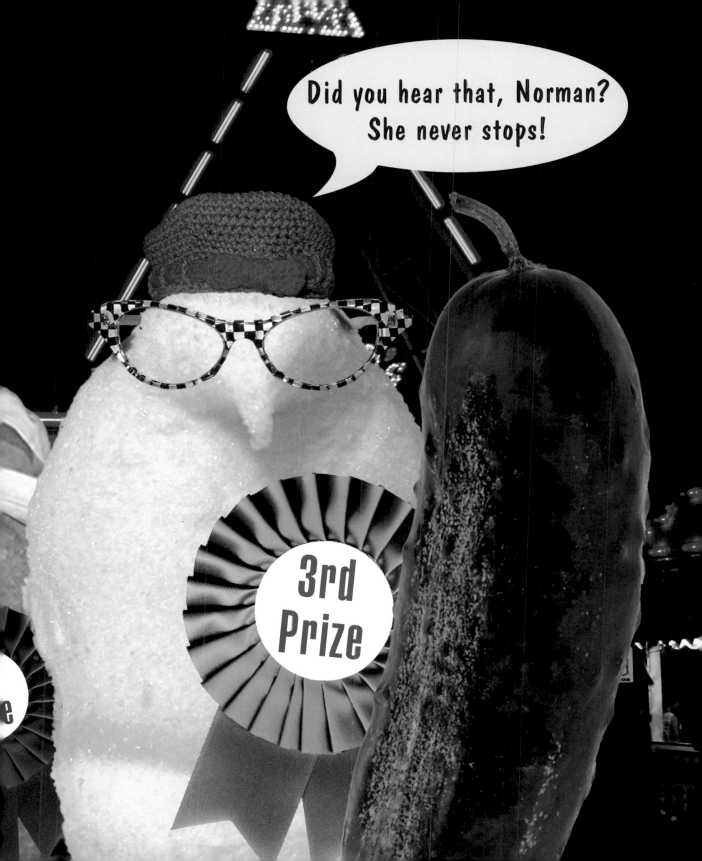

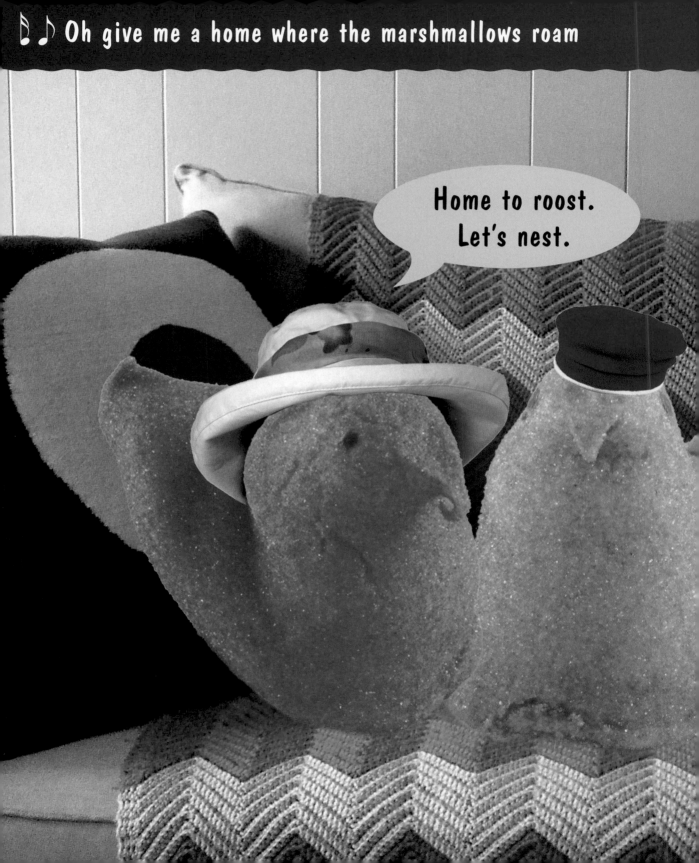

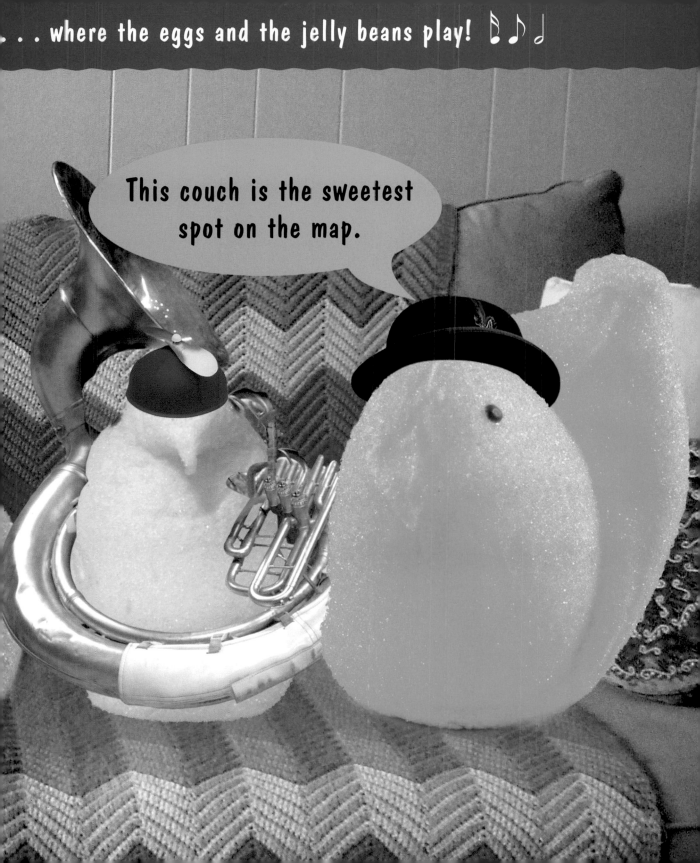

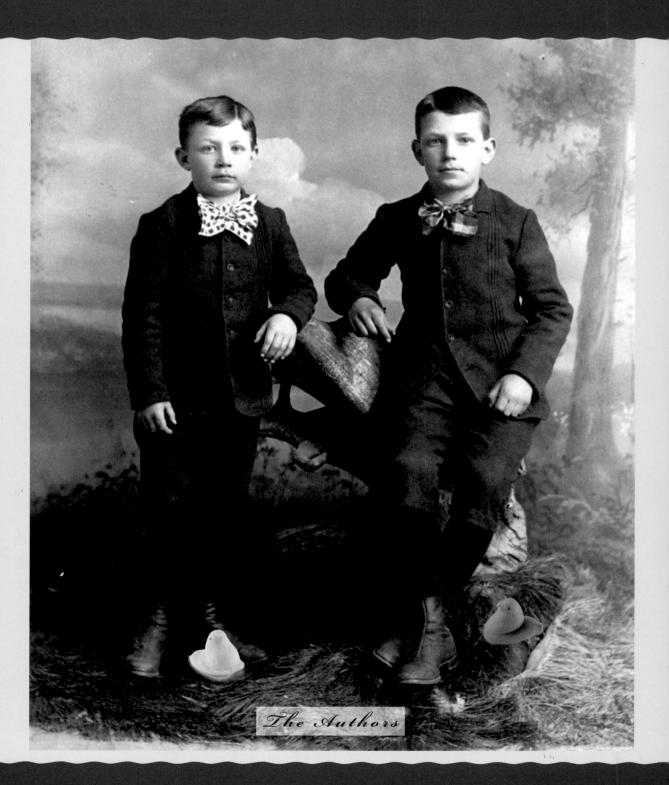
*The Authors*

FOR CAROLINE AND HILLARY

ACKNOWLEDGMENTS

The authors would like to thank Allen at the Red Caboose hobby shop,
Susan Homer, Arlene and Simon Kahn, John Kerr of Just Born, Inc.,
Kiki Pinehurst and Lisa Marks. Special thanks to Amer Khan for his
invaluable photographic contributions and technical expertise.
Portrait of Gianni Gelato
by Miss Olivia Chiossone.

Editor: Howard Reeves
Production Managers: Jacquie Poirier, MacAdam Smith

Library of Congress Cataloging-in-Publication Data:

Masyga, Mark.
Peeps Ahoy! A Candy-Coated Adventure on the High Seas
by Mark Masyga and Martin Ohlin.
p. cm.
ISBN-13: 978-0-8109-9317-4
ISBN-10: 0-8109-9317-1
1. Peeps (Trademark)—Humor. I. Ohlin, Martin. II. Title.

PN6231.P334M38 2008
818'.602—dc22
2007029739

Printed and bound in China
10 9 8 7 6 5 4 3 2

# ABRAMS
THE ART OF BOOKS SINCE 1949

115 West 18th Street
New York, NY 10011
www.abramsbooks.com